Chris Marquardt

Wide-Angle Photography

Capturing Landscape, Portrait, Street, and Architectural
Photographs with Wide-Angle Lenses
(Including Tilt-Shift Lenses)

rockynook

Wide-Angle Photography
Chris Marquardt
www.chrismarquardt.com

Editor: Joan Dixon
Translation: Jeremy Cloot
Interior design: Birgit Bäuerlein
Layout production: Hespenheide Design
Cover design: Hespenheide Design
Illustrations: Peter Marquardt
Project manager: Lisa Brazieal
Marketing coordinator: Mercedes Murray

ISBN: 978-1-68198-383-7
1st Edition (1st printing, August 2018)
All images © Chris Marquardt unless otherwise noted

© 2018 by dpunkt.verlag, GmbH, Heidelberg, Germany
Original German title: Weitwinkelfotografie
German ISBN: 978-3-86490-398-2
Translation copyright © 2018 by Rocky Nook, Inc. All rights reserved

Rocky Nook, Inc.
1010 B Street, Suite 350
San Rafael, CA 94901
USA

www.rockynook.com

Distributed in the U.S. by Ingram Publisher Services
Distributed in the UK and Europe by Publishers Group UK

Library of Congress Control Number: 2017963021

This book is printed on acid-free paper.
Printed in China

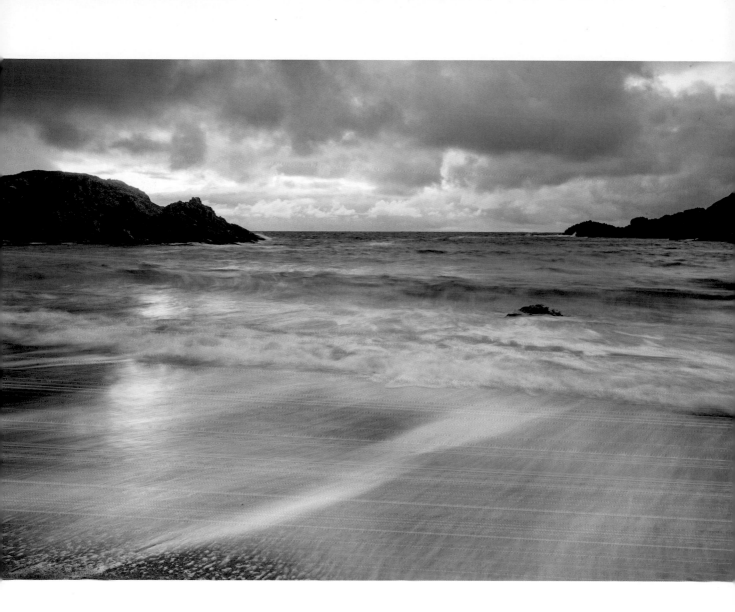

For everyone who is interested
in the *why* as well as the *how*.

Acknowledgments

I would like to thank everyone who took part in the first 24mm workshop. Without you this book wouldn't exist. Thanks also go to Jim Rakete for his early influences and for completing the circle; to the Feelin' Good Bluesband (Martin Kade, Stefan Zenner, Nick Deeg, and Hans Madlinger); Hellmut Hattler; Joo Kraus; Tales in Tones (Ralf Schmid, Veit Hübner, Torsten Krill); Douglas Hopkins for his beautiful images; Ralf Albert for his Frankfurt views; Alexa and Alexander Waschkau for their positive radiance; Ralf Hüls and Boris Nienke for valuable information; Tim Vollmer for the exciting locations; Peter Marquardt for nighttime lines; Marieke Thüne for making contacts; Elisabeth File for freezing patiently; Paul Kelly for the low-level tripods; Richard PJ Lambert for his solar images; Jochen Möller for his hands; 11A for the pretty rear wall. And thanks to Moni for everything else . . . and the empty table.

About the Author

In 2005, I swapped my full-time job for the world of freelance photography. Back then, the relatively new phenomenon called podcasting helped me gain a foothold and find out more about the things I really like to do. In my life as a photographer and photo coach I get to meet many interested and interesting people, and travel with them to the end of the world or, sometimes, just to the next village. At home in the *Viewfinder Villa* [1], there is a constant stream of people who turn up to learn about photography in our many workshops. Topics include composition, dealing with human subjects, and light in general. More exotic topics such as analog large-format photography, photography using film, and the psychology of photography are also covered. For more details about my workshops and photo tours, visit *www.discoverthetopfloor.com*.

Photo: Pax Ahmsa Gether

As a passionate podcaster, I regularly explain how photography works. Every week, my podcast at *www.tipsfromthetopfloor.com* covers a broad range of photographic topics as well as answers to listeners' questions.

For a look into the future, visit *www.thefutureofphotography.com*, where my friend Adrian Stock and I explore the exciting ways new and emerging technologies will shape photography in the years to come.

As a consultant, I advise companies on how to improve their visual image by concentrating on human perception, the basics of great design, and the ways in which images affect various target audiences.

As a producer, I help companies and individuals to convert their ideas into customized images and video.

As a traveler, I help others to travel successfully, either in person or through the images and stories I bring back from my own journeys. Check out my podcasts or other online resources for more details.

Finally, as an author, I can delve much deeper into my favorite topics than my workshops allow. Check out the book *The Film Photography Handbook*, written with my partner Monika Andrae and published by Rocky Nook, Inc.

For more details on all of my activities, visit *www.chrismarquardt.com*.

[1] Throughout the book, these bracketed numbers refer to a list of websites found in the References section of the appendices.

Table of Contents

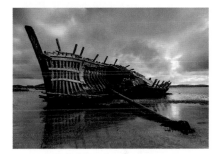

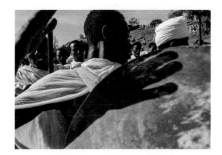

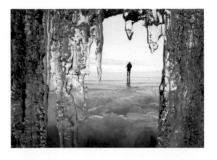

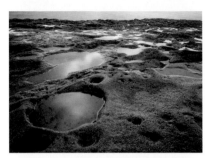

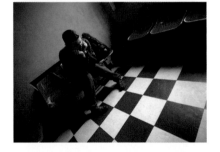

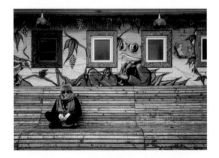

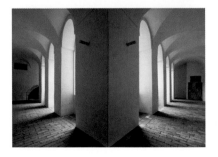

6 Tilt-Shift Part 1: The Basics 143

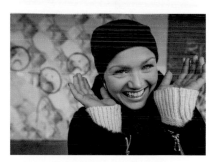

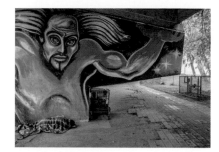

Preface:
Depth Follows Breadth

For me, photography is like a huge imaginary building with an endless number of rooms, corridors, halls, cellars, and lofts. Every time I think I have finally nailed it, another door opens and I discover a previously unknown place to explore.

I learn new things instinctively and I rarely start by using a book. I much prefer to take a hands-on approach and dive straight in. I try out every aspect of a new idea and, while I do read up on things too, I understand things much better if I can see and touch them.

This is exactly the way I approached wide-angle photography. When I left on a long trip and left my zoom at home, I finally made the giant step from simply using a wide-angle lens to actually understanding what wide-angle photography is all about. It wasn't easy to transition from safe and flexible shooting with a zoom to carrying just a single 24mm prime lens.

Looking back, it was one of the best photographic decisions I had made in years. Not only did it nudge me out of my comfort zone, it also helped me overcome the fear of not having the right lens in my bag. Diving into the deep end worked! When you can no longer use the zoom ring to adjust your framing, you have to get creative instead. You either have to physically move or use the available angle of view from your current viewpoint to compose a successful image.

Of course, I sometimes cursed my self-imposed limitation and I sometimes didn't capture the perfect shot. But I ended up with a whole bunch of images that I would not otherwise have made that I am still proud of today.

In fact, that experience was so character-building that I decided to offer a wide-angle workshop that goes into depth on just this one topic rather than covering as much ground as possible. I called my new workshop *24mm* and it has generated lots of positive feedback.

Perhaps surprisingly, getting to grips with this tiny portion of the photo cosmos ended up broadening my overall photographic horizons. I learned about other types of lenses and focal lengths and, as a result, my lens choices are now much more deliberate.

Baikal Ice
(24mm, ISO 200, 1/320 sec., f/5.6)

I hope the in-depth information in this book encourages you to try out and learn all about wide-angle photography, and I hope it helps you deepen your photographic understanding in the process. The best way to learn is hands-on, which is why there are real-world exercises for you to try throughout the book. They only take a few minutes, don't require much equipment, and help demonstrate the techniques described in the text.

How to Approach This Book

Photography is like riding a bicycle or swimming—the best way to learn is by doing, and this book is written with precisely this approach in mind. In other words: become absorbed with the topic, concentrate on the job, and establish a direct route to your nervous system. This book is structured so you can create your own approach. You can begin with the first steps outlined in chapter 1 or you could start with chapter 4 and learn all about architectural photography. There is no need to plough through it from cover to cover—think of it as a launch pad to a journey of discovery. Don't worry if you prefer to approach things linearly—the sequence of the chapters is designed to make sense if you prefer to take a conventional tack.

This book contains virtually no formulas. It is much more important that you understand the links between the topics involved, and the best way to do that is to grab a camera and try things out.

Chapter 1, *First Steps*, is aimed at getting you started with wide-angle photography. It provides the tips you need to get up and running with capturing your own wide-angle shots, regardless of whether you use a DSLR with a prime lens or a super-zoom bridge camera.

Chapter 2, *What is Wide-Angle All About?*, helps to explain the role wide-angle photography plays in the overall photographic universe. It explains the relationship between angles of view and sensor sizes, the similarities between your camera and a movie theater, why crop factors don't alter focal lengths, and when a 150mm lens is considered a wide-angle. This chapter also includes a short detour into the psychology of photography.

Chapter 3, *Creative Challenge*, gets back to hands-on basics. This is where you will learn why short focal lengths make for big subjects, how wide-angle lenses affect depth of field and lighting, and how to master the compositional issues these lenses raise.

Chapter 4, *Wide-Angle Lenses in Practice*, delves into shooting landscapes and architecture using wide-angle lenses. We also take a look at unusual uses for wide-angle lenses, such as portrait and street photography.

Chapter 5, *The Technical View*, takes a look at the technical side of wide-angle photography. Among other things, we investigate what focal lengths have to do with angular velocity, why the angle of incidence of light rays on the sensor affects vignetting, and the relationship between

focal length and depth of field. It also includes how to capture wide angles of view without using a wide-angle lens.

Chapters 6 and 7, *Tilt-Shift Basics* and *Tilt-Shift in Practice*, might sound exotic, but actually have more to do with wide-angle photography than you might think. Shifting the image circle enables us to use angles of view in completely new ways, making it simple to eradicate converging lines in wide-angle photos. A 24mm tilt-shift lens is a staple tool in the worlds of landscape and architectural photography, but we take a look at the benefits of shifting the image circle and tilting the plane of focus with other focal lengths, too.

Who This Book is For

This book is for everyone who . . .

- wants to deepen their understanding of wide-angle photography.

- isn't afraid to try out new techniques.

- wants to capture subjects with a depth and breadth that make viewers gasp.

- wants to learn more about choosing lenses.

- wants to broaden their photographic horizons by adding new skills.

- prefers to discover things using gut feelings and a hands-on approach.

This book does not offer a detailed collection of formulas for calculating the optical characteristics of photographic lenses. In fact, the book contains virtually no formulas at all. Where necessary, all calculations are illustrated using simple comparisons and self explanatory images.

Photospeak

Experienced photographers can skip this part, but for all those who are new to the game, here are explanations of some common photographic terms.

- Focal lengths are measured in millimeters (mm).

- We often describe how *wide* the angle of view of a lens is, but seldom refer to how *narrow* it is, which is actually a more accurate description.

- Lenses with wide angles of view (i.e., wide-angle lenses) are often referred to as *short* lenses. At the other end of the scale, telephotos are referred to as *long* lenses.

- Lenses with a wide maximum aperture allow in plenty of light and are consequently described as *bright* lenses.

- When photographers refer to *glass* they are usually talking about lenses rather than drinking vessels. Specialist's terms are often used in combination so don't be surprised if you hear photographers talking to one another about *bright glass*.

- The word *crop* on its own refers to the process of editing the absolute dimensions of an image. But the word has a second meaning. The size of the camera's image sensor influences the angle of view. Sensors that are smaller than the standard 35mm (full-frame) size are often referred to as *crop sensors*, and the *crop factor* is the factor required to calculate the crop focal length with an equivalent 35mm angle of view.

- *Full-frame* and *35mm* mean the same thing when it comes to film and sensor sizes. However, *35mm* is used more often in analog circles, while *full-frame* is more commonly used in the digital world.

- *Depth of field* refers to the area that appears to be in focus in front of and behind the main subject in an image.

- The main motif in an image is usually referred to as the *subject*. The subject of a portrait is a person, while the subject of an advertising photo is the product.

- The process of merging multiple photos into a single wide-angle panorama image is called *stitching*.

- Japan is the home of significant parts of the camera manufacturing industry, and Japanese terms play a role in photography, too. The most important of these is *bokeh* [2], which means *blur* and is used to describe the out-of-focus areas found in the background of many images.

- *Focal length* is a term you are bound to hear. As a kid, did you ever set fire to a sheet of paper using a magnifying glass to focus the sun's rays? The ideal, fire-starting distance between glass and paper is the focal length of the magnifying glass. In photography, it is the measurement from the point at which a lens focuses to the center of the lens.

- *Perspective* gives the sense of depth or spatial relationships in a two-dimensional image. To alter the perspective in an image you have to alter the position of the camera. Simply zooming in and out (i.e., altering the focal length of the lens) alters the framing but not the perspective.

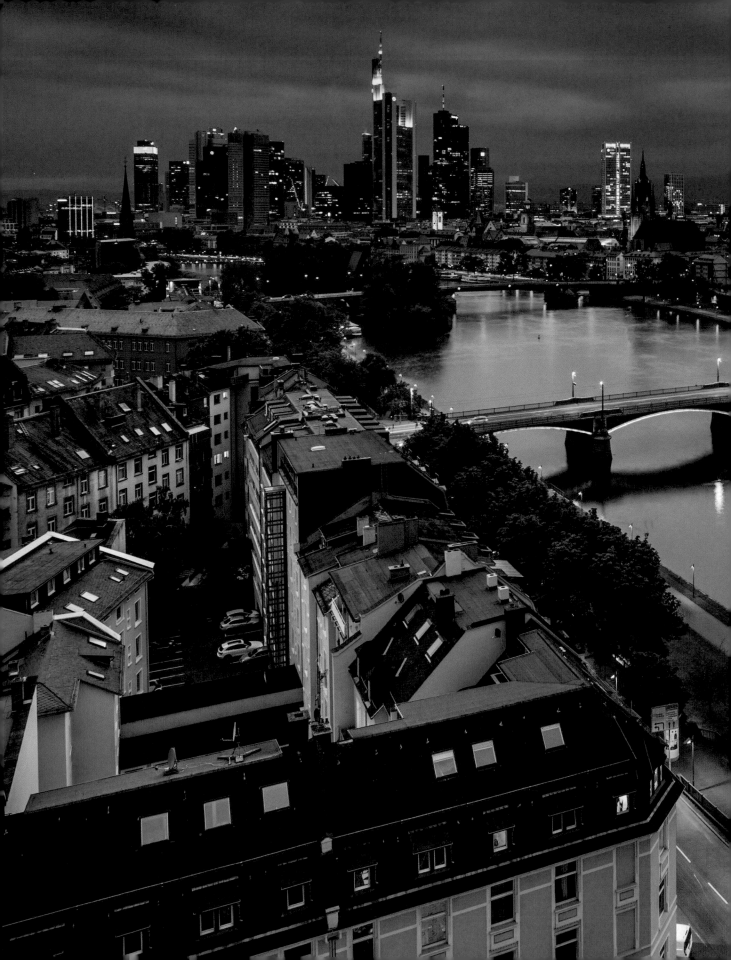

Chapter 1
First Steps

📷 Previous Spread:
Figure 1-1: Frankfurt
(24mm, ISO 100, 30 sec., f/8)

Have you acquired a new wide-angle lens that you can't wait to try out? Or have you noticed that your camera's kit lens can do 18mm, too? Or have you discovered your grandfather's old wide-angle in a box somewhere? It is essential to get on intimate terms with your photo gear and to find out about what it can do. Only then can you react quickly in any situation and utilize the full potential of your kit. Take time to get to know the capabilities and the pitfalls of your wide-angle lens.

Figure 1-2: An analog Nikon FE2 fitted with a 20mm wide-angle lens.

The best thing to do is to dive right in. The following sections will help you get started, and the exercises that are included will get you up and running.

1.1 Differences in Depth

Wide-angle lenses alter the appearance of depth in an image. The distances between objects within the frame appear greater than when you shoot using longer focal lengths. You can use this effect to make objects look larger than they actually are. Don't be afraid to get right up close to your subject and use the close focus limit of your lens to the full.

Try this experiment: take your camera, your wide-angle, and a longer (perhaps short telephoto) lens. If you don't have multiple lenses, you can use your kit zoom instead. Starting with your wide-angle lens, choose a subject and take some shots from as close as your lens allows. Now, using the longer lens, increase your distance to the subject and take the same shot (i.e., make the subject appear the same size within the frame).

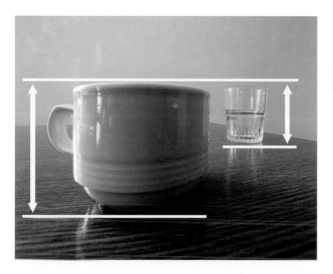 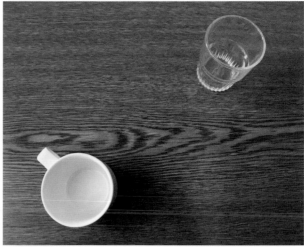

Figure 1-3: Captured using a wide-angle lens, the mug appears much larger than the glass in the background.

Figure 1-4: Capturing both objects at the same distance from the camera shows that they are actually about the same size.

When you check the results, you will clearly see how the different focal lengths affect the feeling of depth in an image. See chapter 3 for more details on this topic.

1.2 Angles of View and Context

Wide angles of view naturally include more detail in the frame. Sometimes, too much detail can have a negative effect and may distract the viewer's attention from the main subject. Pay special attention to the details surrounding the main subject when composing a wide-angle image, and don't forget to compose the edges of the frame and the background, too. Less is usually more!

Select a subject close at hand and try out various compositions using your wide-angle lens. Take some shots that deliberately include lots of detail and then try again with fewer objects in the frame. Without getting any closer, change your position to include fewer elements.

On the other hand, plenty of detail provides context, which can help to underscore the message in an image, or even give it its relevance in the first place. In other words, don't just play around with the amount of stuff in the frame—consider carefully how the objects in the frame are placed and what they are saying. See chapter 3, *Creative Challenges*, for more on this topic.

Figure 1-5: Wide angles of view often capture too much distracting detail in the frame. The aim in this image was to use the strong line in the foreground to guide the viewer's eye to the yellow pipes. However, the wide lens makes the pipes appear too small to be significant. The image appears chaotic and lacks a visual center.

Figure 1-6: In this case, careful composition and the limited number of visual elements produce a much cleaner image.

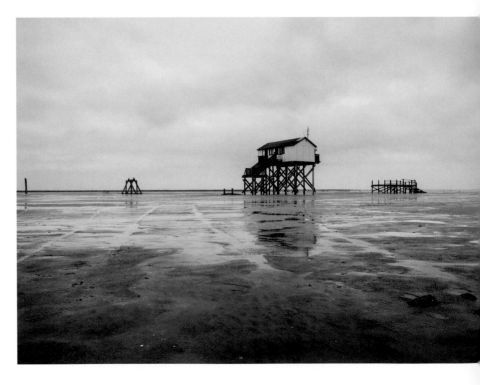

1.3　Sharpness and Context

Long and short focal lengths produce very different depth-of-field effects. While a telephoto lens produces distinct background blur, a wide-angle captures much more depth of field. In turn, this produces a sharper background and thus alters the context surrounding the subject. The sharper the foreground and background details, the more they compete with the main subject for the viewer's attention. You can influence the degree of background sharpness by altering the size of the aperture and the distance to the subject. The larger the aperture and the closer you get, the more background blur you will have.

Try shooting a subject using your wide-angle lens at different apertures and at various distances. Use aperture-priority mode for this experiment.

The larger depth of field and skewed proportions produced by wide-angle lenses are great for creating so-called *forced perspective* shots. For example, making it look as if a friend is propping up the Leaning Tower of Pisa. Increased depth of field makes it possible to capture objects at different distances from the camera with a similar degree of sharpness.

Figure 1-7: A large aperture blurs the background.

Figure 1-8: The sharp background distracts from the main subject.

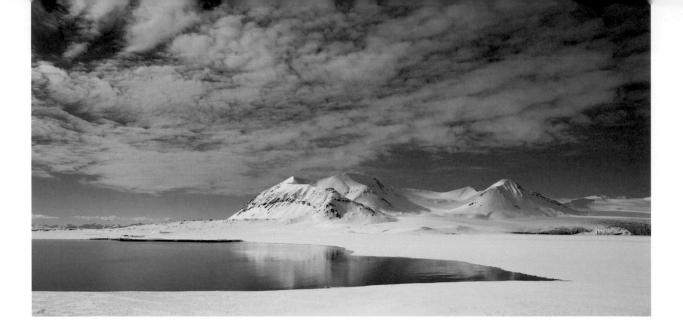

1.4 Landscapes and Composition

Wide-angle lenses are popular for landscape photography, so let's take a look at context, image depth, and composition from a landscape photographer's point of view. Landscapes usually consist of obvious foreground and background elements, often separated by the horizon. If the sky, with its dramatic cloudscape, is more interesting than the rest of the frame, you can compose your image accordingly and give the sky more space.

Figure 1-10: One way to deal with an uninteresting sky is to simply leave it out.
(24mm, ISO 400, 1/200 sec., f/4)

Try it out by capturing a landscape, first giving priority to the sky and then to the foreground. Make sure that the horizon is parallel to the top or bottom edge of the frame. For more on wide-angle landscape photography, see chapter 4, *Wide-Angle Lenses in Practice*.

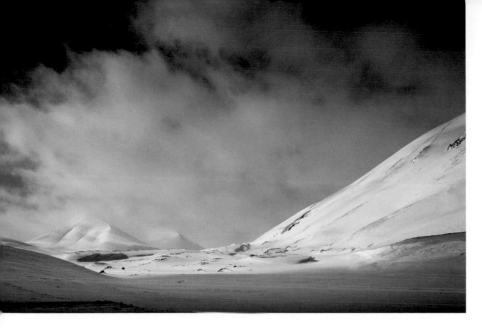

Figure 1-11: Distortion is not a big issue in most landscape shots.

1.5　Barrel Distortion

The way wide-angles are built often causes barrel distortion, especially at ultra-wide-angle focal lengths. This effect makes straight lines that are parallel to the edges of frame appear curved. The closer such a line is to the edge of the frame, the more obvious the effect. This is often a problem in architectural shots, but can be irrelevant in other contexts. For example, nature photos often contain very few (or no) straight lines.

It is important to be aware of how strongly your lens distorts straight lines when they do appear. The best way to test distortion is to photograph bathroom tiles. Set up your camera parallel to the wall and compare the lines in the middle of the frame with those at the edges. If your lens produces obvious distortion, don't worry—barrel distortion is relatively easy to correct using image-processing software, and some cameras even have built-in distortion correction.

Figure 1-12: Bathroom tiles make a great subject for checking wide-angle lens distortion.

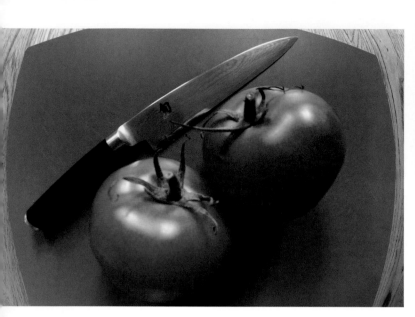

Figure 1-13: Captured with heavy distortion using an action cam.

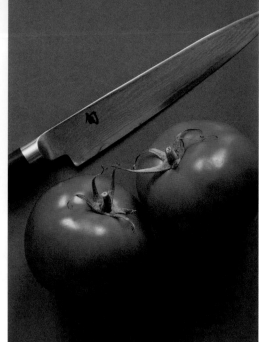

Figure 1-14: The same image using a 50mm normal lens.

1.6 Using Depth and Distortion Creatively

Distortion isn't always a problem. Heavy barrel distortion can be used deliberately as a creative tool, and is an integral part of much of the sports footage shot using action cams. Used in combination with the special depth-of-field effects that wide-angle lenses produce, distortion can be a lot of fun—in portrait shots, for example.

Take some test shots using a normal lens (i.e., a 50mm model if you are shooting full-frame), and again using your wide-angle. If you have access to a fisheye lens or an action cam, try those, too. Make sure your subject appears the same size in the frame in every shot. The wide-angle versions will produce a completely different, almost comedy-like effect compared to the one created by the normal lens.

Figure 1-15: Even using a 14mm lens, the coffee table appears circular when captured in the center of the frame.

Figure 1-16: The closer the subject is to the edge of the frame, the more distorted it appears.

1.7 Distortion at the Edge of the Frame

The wider the angle of view of your lens, the more distorted lines at the edges of the frame will become. Playing with this effect can be a lot of fun.

Try shooting a subject at different positions within the frame, including at the top, bottom, sides, corners, and center. Distortion effects are particularly obvious in portraits, and human subjects often look weird when photographed this way. Use varying focal lengths and distances to keep the subject size constant within the frame. The shorter the focal length, the more prominent edge distortion will be.

What Are Wide-Angles All About?

Perhaps you are familiar with situations similar to the following: You are planning a trip to the Grand Canyon, you have seen plenty of impressive photos of this location, and you want to use your new wide-angle lens to capture our own. Once you reach your destination, you are deeply impressed by the sheer depth and breadth of the landscape and begin to snap away using your new 12mm. Back home, you are disappointed to find that little of that breathtaking breadth and depth is seen in your images. Worse still, your best photos only get a lukewarm reaction from your friends.

In order to understand what has happened, let's take a closer look at how to capture real-world depth and breadth in photos. To do this, we will approach the subject of wide-angle photography from a number of different directions.

To begin, we will use the human eye as a reference point for our wide-angle experiments.

The stated focal length of a lens represents a mathematical way to express its capabilities. The following sections will teach you how to develop your instinct for focal lengths, and how to recognize the circumstances under which low numbers aren't as wide-angled as you might expect.

We will also look at wide angles from the point of view of human perception and demonstrate that it isn't necessarily related to the camera or the lens at all.

2.1 The Human Eye

Put down the book for a moment and take a look around you. Turn your head and check out the room you are in. How wide do you think your field of view is? Without turning your head, which objects can you still just about see out of the corners of your eyes? How many degrees does your view cover?

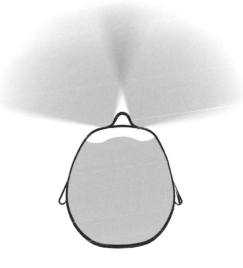

Figure 2.1: A pair of human eyes covers a field of view of approximately 180 degrees.

Under normal circumstances, humans have a horizontal field of view of about 180 degrees. In other words, we see things in a widescreen, wide-angle way. What we see is the result of two images (one from each eye) being merged together by our brain. This is different from the way the camera sees the world with its single lens. Getting to know the similarities and differences between a camera and the human eye will help you understand how wide-angle photography works, and ultimately to shoot images that will blow you and your friends away.

Like your eyes, your camera uses a lens to focus an image. Your retina performs the same function as the image sensor (or film) and forms the surface on which the image is projected. But that's pretty much where the similarities end. While the camera's lens is made of hard (i.e., static) glass, the lens in your eye is flexible and alters its focal length when you tense or relax its muscles. Furthermore, the retina in your eye is curved, whereas the sensor or film in your camera is flat.

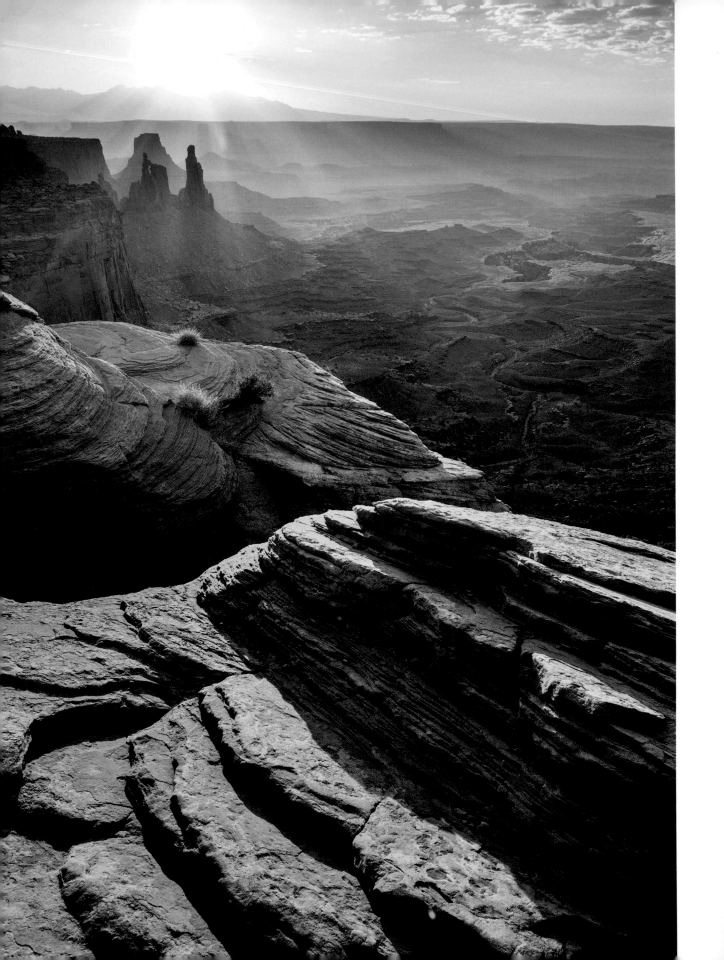

In addition to your eyes, your brain plays a huge role when it comes to using your human visual apparatus to view and evaluate images. Vision is our most important sense, and more than half the brain is involved in the process of visual perception. As well as seeing things we have to interpret them, too, so it is a mistake to reduce the notion of human perception to just the mechanical process of seeing. This concept is perhaps easier to understand in the context of pseudo-wide-angle vision. For more details on this topic, see section 2.4.

Figure 2.2: Canyonlands National Park, Utah
(24mm, ISO 400, 1/100 sec., f/5.6)

The Wow Effect

Getting back to the Grand Canyon: I have, in fact, only ever been to the Canyonlands National Park in Utah, which is said to be just as spectacular but isn't as crowded.

The desire to capture the experience of being there and sharing it with others becomes immediately clear to anyone who has stood at the edge of Island in the Sky. It is extremely difficult to describe the sheer size of such a landscape and the impact it has on its visitors. Unfortunately, it is just as difficult to capture the moment in a photo in a way that adequately conveys the experience.

One of the reasons such a landscape is so breathtaking is that it completely fills our wide-angle field of vision. Another reason is that we have no references to compare it with. These canyons, with their glowing red walls, are some of the most imposing landscapes in the world.

When capturing a landscape like this with a camera, the act becomes a multi-sensory experience. We see the scene in three dimensions, we hear and feel the warm desert wind, we smell the air, and we hear and feel the crunch of the sand under our feet. We then link these memories forever with the photos we capture. When we get back home, every time we view our photos we recreate the experience in our minds, which is why we see them differently than other people who weren't there at the time.

An independent viewer has only a two-dimensional image to look at, and cannot draw on the mass of input you have from actually having been there. Your job as a photographer is to capture images that convey at least some of this missing sensory data. For more on how to do this, check out section 4.1, *Landscapes*, where we take a look at strategies for capturing real "wow" in your images.

2.2 Focal Lengths

Visual input is important, and the following sections look at it with the help of the photographic metric called focal length. Technically speaking, the focal length of a lens is the distance between the lens and its focal point. If a magnifying glass focuses the sun's rays on a sheet of paper from a distance of 10cm, the focal length of the glass is 10cm (i.e., 100mm). In photographic lenses, the lower the number of millimeters the wider the angle of view. However, an 18mm lens is not always a wide-angle and can, under certain circumstances, even be classed as a telephoto.

2.2.1 Normal Lenses

In order to create a scale of values for anything at all, it is always useful to establish a *normal* value first. A *normal* focal length lies between the two extremes of telephoto and wide-angle, and is derived from the diagonal measurement of the camera's sensor. Popular wisdom often holds that the normal focal length is the one that best represents the way the human eye perceives its surroundings. However, this definition is rather vague and has its drawbacks. We will take a closer look at it later on.

Figure 2.3: The normal (or standard) focal length for any camera is approximately equal to the diagonal size of its sensor. In a full-frame camera, this measures approximately 43mm.

First and foremost, it is essential that normal focal length be defined in relation to the size of the camera's sensor or film format. For full-frame/35mm cameras with a frame that measures 24×36mm, the normal focal length equates to approximately 43.3mm. For a Micro Four Thirds camera with a sensor measuring 17.31×12.98mm, the normal focal length is 21.6mm. In practice, these values are usually rounded up or down. Most full-frame cameras use 50mm normal lenses, while Micro Four Thirds cameras settle for 25mm. This shows us that normal focal lengths vary from sensor type to sensor type.

Regardless of the sensor format, what all normal lenses have in common is that they portray a similar angle of view at a similar magnification, and thus produce similar-looking images. Your model will appear the same whether you capture a portrait using a full-frame camera and a 50mm lens or if you capture the same shot from the same position using a Micro Four Thirds camera and a 25mm lens.

The 50mm normal lens often used with a full-frame camera is sometimes referred to as the *nifty fifty*—a name that gives some clues as to just how useful a normal lens can be. Traditionally, 50mm prime lenses are bright and have a maximum aperture of f/1.8, f/1.4, or even f/1.2. An f/1.8 normal lens is cheaper than its brighter counterparts and is an essential part of every full-frame photographer's kit.

Exercise

For this exercise, you need a smartphone and a camera with a normal lens.

Using each of the devices, capture the things on your desk from a distance of about eight inches and then compare the results. The differences in size between close and distant objects will appear the same in both images. What differences do you see?

Normal Focal Lengths for Popular Photo Formats

- **Smartphone:** With sensor diagonals and normal focal lengths of 6–10mm, phone camera sensors are some of the smaller ones we encounter in everyday life. Because the focal length of a phone camera's lens influences the thickness of the device, fitting more powerful cameras into phones that are constantly getting thinner presents an insurmountable technical conflict. This is why many current smartphones have a prominent camera bump.

- **Four Thirds:** The diagonal of a Micro Four Thirds sensor is half the length of the full-frame diagonal, resulting in a crop factor of 2. The mathematical normal focal length for a full-frame camera is 43mm, whereas it lies between 20mm and 25mm for a Four Thirds camera.

- **APS-C:** The size of APS-C sensors varies from manufacturer to manufacturer. Canon's version measures 22.5×15mm, while Nikon's measures 23.2×15.4mm. The respective crop factors are therefore 1.6 and 1.5 at a normal focal length of around 30mm.

- **Full-Frame/35mm:** The 24×36mm format has been the gold standard of camera formats since Leica used the then-standard movie film format in its first stills camera prototypes in 1914. The diagonal of a 35mm film frame is slightly shorter than the normal 50mm focal length.

- **Medium Format:** In the analog world, the term *medium format* refers to the 120 roll film format, which is 6cm high and is used to capture images that are either 4.5cm or 6cm wide (or 12cm in specialized panorama cameras). The equivalent diagonals measure between 75mm and 130mm. The most widely used analog medium-format normal lenses have a focal length of 80mm.

 Digital medium formats are slightly smaller, with sensors measuring between 36×48mm (with a 60mm diagonal) and 54×40mm (with a diagonal that measures 67mm).

- **Large Format:** Although the large format scene is still very much alive and covers a whole range of different film types, the standard large-format film is still the 4×5 type, with a diagonal of about 5.9" (162mm). For this format, 150mm normal lenses are the most widely used.

Fore more details see appendix B, *Normal Focal Lengths for Popular Camera Formats.*

2.2.2 Depth not Breadth

Since I acquired my first single-lens reflex (SLR) camera, I have been constantly confronted with the claim that normal lenses portray the world the same way we perceive it through our eyes. For a long time, I accepted this idea as an incontrovertible truth of photography, but I was often annoyed when the images I shot using a 50mm lens didn't make my subjects look the way I saw them with my eyes.

This concept begins to crumble the moment you begin to consider angles of view. The field of view covered by a 50mm normal lens is between 40 and 50 degrees across, which does not equate to our human field of view of around 180 degrees. In other words, the comparison between a normal lens and the human eye has severe limitations.

A more accurate way to express the behavior of a normal lens is to consider how it reproduces depth effects. And this comparison between a lens and the human eye holds up. A normal lens reproduces the appearance of distances between objects that are at varying distances from the camera very similarly to how we see them.

The difference is one of the reasons images of the Grand Canyon turn out so disappointing. Not only does a wide-angle lens increase the angle of view, it also increases the perceived depth and the distances between objects within the frame; and the wider the angle, the greater the effect. Objects close to the camera appear much closer and larger than they actually are, while distant objects appear much smaller and farther away. In the context of the Grand Canyon, this effect gives the railing in the foreground too much emphasis, while the canyon itself disappears into the background.

2.2.3 Crop Factors

Whenever you research focal lengths and sensor sizes, the term *crop factor* turns up repeatedly. Misleadingly, the crop factor is often brought into direct relation with the focal length of the lens. However, a 50mm lens is not magically transformed into an 80mm lens when it is used with a camera that has a crop factor of 1.6. The focal length of the lens remains constant and the size of the sensor cannot change this.

What does change is the angle of view. From the same position, a smaller sensor simply captures less of the scene in front of the camera. In other words, a 50mm lens used with a camera with a crop factor of 1.6 has an angle of view equivalent to that of an 80mm lens used with a full-frame sensor.

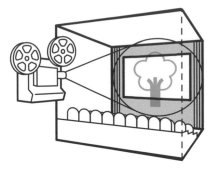

Figure 2.4: A camera is similar to a movie theater in that an image is projected from one side of a space onto the opposite side.

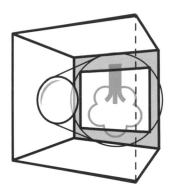

Figure 2.5: A camera is a light-proof box that captures an image projected from the one side of the box onto the other.

Figure 2.6: The larger the sensor, the more of the image circle projected by the lens it captures. An APS-C sensor sees less of the image circle than a full-frame sensor, which in turn captures less than a medium-format sensor.

A Camera Is like a Movie Theater

To illustrate the effect the sensor size has on the angle of view, try the following thought experiment: imagine you are sitting in a movie theater in which the projectionist can change the size of the screen at the push of a button. Black bars move into the image from all four sides and limit the projection area, but nothing else changes. Neither the focal length of the lens nor the distance between the projector and the screen are altered: we just see less of the projected image. In other words, the angle of view is reduced. If the projectionist moves the black bars outward, the screen is enlarged, and we see more of the image, which is equivalent to using a wider angle of view.

If we apply this idea to a camera, the lens represents the projector, the sensor represents the screen, and an image of the outside world is projected by the lens onto the sensor. If we reduce the size of the sensor, nothing happens to the projected image. The lens and its focal length remain the same, and they project an unchanged image onto the sensor.

Altering the size of the sensor while keeping all other factors constant alters the angle of view. In other words, the same lens used with a camera that has a larger sensor behaves as if it has a wider angle of view.

Appendix C includes a table of crop factors and the equivalent focal lengths they produce with a range of popular sensor formats.

The terms *effective focal length* and *equivalent focal length* usually refer to the focal length that results when the crop factor has already been included. For example, a 50mm lens used with a Micro Four Thirds camera has an effective focal length of 100mm. Take care when purchasing lenses, as some vendors advertise their products using *effective* rather than *absolute* focal lengths.

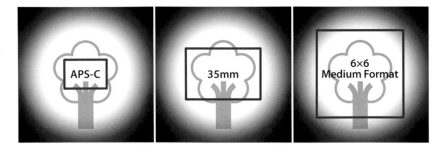

2.2.4 Classifying Focal Lengths

To fully understand wide-angle lenses, we need to take a look at other focal lengths, too. In this section the full-frame sensor format is used as a reference and helps to explain terms such as *ultra-wide-angle*, *fisheye*, and *mirror lens*. The 24×36mm full-frame format is the industry-wide standard against which other formats are compared. Unless otherwise noted, this is also the case throughout this book.

The 24×36mm full-frame format is the de facto standard used to compare sensor formats, and it is interesting to note how digital formats have evolved to mimic analog systems, albeit from a completely different direction. Analog film photography has its origins in much larger formats, and the 35mm (full-frame) format only came into use much later on. There are ergonomic and economic reasons for this. Smaller film formats contain less silver and enable the construction of smaller cameras and lenses that are easier to carry. Digital photography has taken the opposite path; starting out with very small sensors and, as production techniques improved and costs were reduced, branching out to include ever larger sensors. The first genuinely affordable full-frame cameras only became available in 2005.

Despite its frame dimensions of 24×36mm, the term *35mm film* refers to the overall width of the material. The 24mm side of the frame lies perpendicular to the direction of travel of a 35mm film, leaving space for the perforations that enable film to roll within the camera. Analog movie film today uses the space next to the image and between the perforations to save various data, including analog and digital sound tracks.

Figure 2.7: Photo: Rotareneg, under license from Creative Commons
Source: Share Alike 3.0 Unported. Source: https://en.wikipedia.org/wiki/File:35mm_ film_audio _macro.jpg

Figure 2.8: A 35mm (full-frame) image measures 24×36mm, and the film itself is 35mm wide. The space at the sides is used to accommodate the perforations used to roll the film within the camera.

Table 2.1: Focal length ranges in 35mm (Full-Frame) cameras. Please note that these values are not absolute and only denote generally accepted ranges.

Type	From (mm)	To (mm)
Fisheye	. . .	10
Ultra-Wide-Angle	10	24
Wide-Angle	24	40
Normal	40	70
Telephoto	70	300
Super-Telephoto	300	1000
Mirror	1000	. . .

Wide-Angle

Full-frame focal lengths between 35mm and 24mm are regarded as moderate wide angles. The angles of view involved range from around 54 to 73 degrees. Due to their popularity in documentary situations, these are often referred to as reportage lenses. They are extremely versatile and are often used for street and landscape photography, as well.

Ultra-Wide-Angle

Focal lengths of less than 24mm are generally classed as ultra-wide-angle, covering angles of view of 80 degrees and more. A 12mm lens used with a full-frame camera has an enormous angle of view of 122 degrees. Unlike fisheye lenses, ultra-wide-angle lenses reproduce straight lines so they look straight in a photo.

Fisheye

A fisheye is the most extreme type of wide-angle lens. It produces images with severe distortion that increases toward the edges of the frame, and has an angle of view often greater than 180 degrees. If you don't watch out, you are likely to end up photographing your own feet when you use one of these. The closer straight lines are to the edges of the frame, the more curved they will appear in the final image. The image circle produced by a fisheye lens is so small that it often doesn't cover the entire sensor, and the resulting images are circular with a dark perimeter. Nikon's legendary 6mm NIKKOR lens has an amazing 220-degree angle of view.

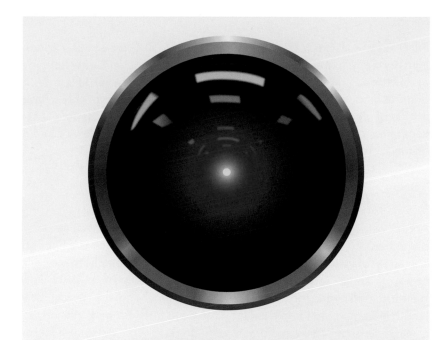

The NIKKOR 8mm f/8 fisheye lens came to prominence when film director Stanley Kubrick used one in his film *2001: A Space Odyssey* to represent the face of the onboard computer HAL 9000. Interestingly, the scenes shot from the viewpoint of the computer were captured using other lenses, not the fisheye.

Telephoto

Moving on from short and normal focal lengths, we hit the realm of short and medium telephotos. These begin at focal lengths of around 80mm and encompass everything up to about 200mm. These lenses have angles of view between 10 and 25 degrees and, as we will see later, have plenty to offer, especially for photography beginners.

Super-Telephoto

The range between 200mm and 1000mm is usually referred to as super-telephoto. These lenses are used to bring distant subjects closer—for example, for sports, wildlife, and photojournalism subjects. Used with custom mounts, these lenses are also used for astrophotography applications. They have angles of view between 2 and 7 degrees.

Mirror

Focal lengths above 1000mm are usually covered by lenses that capture light rays from extreme distances, which use the same mirror technology as telescopes. These lenses have tiny angles of view of less than 2 degrees and offer very high magnifications. The longest lenses have angles of view that are often as narrow as one-tenth of a degree. As a comparison, if you hold a pea at arm's length, an angle of view of about half a degree is required to view it completely.

2.3 Angles of View

Angles of view are an important factor in human vision as well as in the discussion of optical focal lengths, which is what this book is all about. The angle of view of a lens determines whether it is a telephoto, normal, or a wide-angle. Together with the size of the sensor, the angle of view is determined by the focal length. In a slim smartphone, the normal focal length (50mm in a full-frame camera) can be as little as 6mm. In contrast, a 90mm lens can easily serve as a wide-angle when used with a large-format or 4x5 film camera. Normal lenses for large-format cameras have focal lengths of around 150mm. An 8"×10" large-format camera has a normal focal length of 320mm.

Why the Human Eye Is Not Like a Wide-Angle Lens

Let's head back one last time to the Grand Canyon. Why is it so difficult to capture this landscape with a camera in a way that conveys at least some of the spectacular experience to the viewer?

This is basically due to the following three factors:

1. Human vision has a very wide angle of view but still retains the real-world proportions of the objects being viewed, which in turn affects the perceived depth of a scene.

2. A lens with a comparable angle of view depicts the depth of the scene in a very different way to our eyes. To produce comparable depth of field, we would have to use a much narrower angle of view, which in turn would severely reduce the breadth of the captured scene.

3. Alongside these technical aspects, human perception plays a significant role, too. Our feelings about a real-life scene are immediate and subjective, whereas the viewer of a photo has access only to a two-dimensional image but no memories of the actual location.

2.4 Perceived Wide Angles

One extremely important point to make is that wide-angle images are not only created by technical factors, but also by human perception. Some images simply appear wider than they actually are. This perceived wide-angle feeling is rarely discussed, primarily because it is much more difficult to describe than the technical relationships between human vision, focal lengths, and angles of view.

Human perception plays a significant role in the way we see images. We are very good at recognizing patterns, and we tend to mentally fill in the blanks when we are confronted with incomplete visual data. Without this ability, the human race would probably not have survived as long as it has. In prehistoric times, people had to be able to recognize an approaching saber-toothed tiger out of the corner of an eye based simply on its color and the way it moved, just as a contemporary person recognizes an approaching car from a fleeting movement and the sound it makes. Our perception completes the picture. Just as we make a complete figure

Figure 2.10: The viewer cannot see the limits of the depicted scene, which makes it appear larger than it really is. This effect is evident when you compare this image with the one on the next page.

Figure 2.11: The moment we can see the entire subject we understand the illusion produced by the previous image.

out of a human profile that is half covered by a tree, we also assume that lines and surfaces with limits we can't see continue beyond our field of vision.

Photographers can use this phenomenon to their advantage by deliberately getting viewers to work out the proportions in an image for themselves. Even when using a medium wide-angle lens, clever framing makes it possible to force the viewer to perceive the objects within the frame as longer or larger than they really are. In this case, the wideness of the angle is a figment of the viewer's imagination.

Exercise

Select a surface such as a wall, and photograph it so that its limits are visible, and photograph it again so that the limits extend beyond the frame. Which image appears wider?

Figure 2.12: Chicano Park, San Diego, California
(24mm, ISO 400, 1/4000 sec., f/5.6)

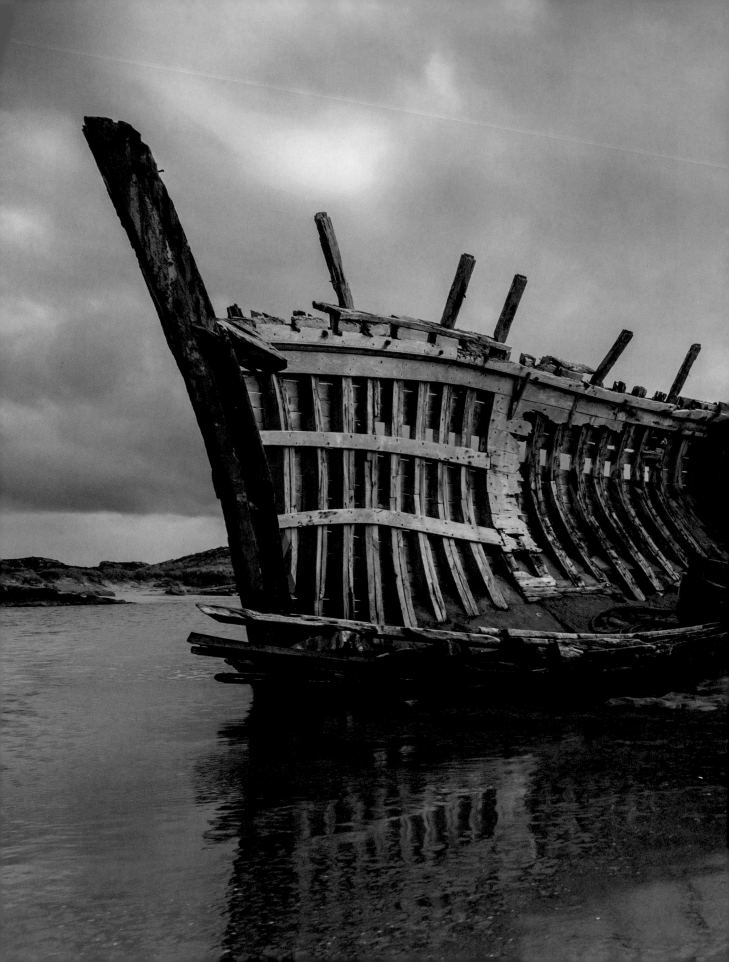

Chapter 3
Creative Challenges

Previous Spread:
Figure 3-1: Bad Eddie's Boat,
Donegal, Ireland
(24mm, ISO 100, 1/60 sec., f/7.1)

We shoot images in order to have an effect on the viewer, to tell stories, or to generate emotion. We have a whole arsenal of tools to help us achieve this and the content of our pictures is at the top of the list. For example, grandparents will always like a photo of their grandchildren, even if little care was taken while composing and shooting it.

Alongside the content of an image, its composition has a powerful effect on the viewer, too. Careful placement of objects within the frame helps to influence what the viewer sees as important and underscores the photo's message.

Wide angles of view don't always help when it comes to producing clean, punchy images, and they often fill the frame with more content than we are used to. As a result, this may have an adverse effect on our instinctive sense of order. If you are used to shooting with longer lenses, your initial wide-angle experiments can appear chaotic and lacking in meaning. The increased depth of field makes visual separation of the subject and the background more difficult, lines appear to become skewed, and the question of lighting takes on a new life of its own.

This chapter addresses composition, angles of view, close and distant objects, and image depth in general.

3.1 Distance

The greatest compositional challenges presented by wide-angle lenses are the increased number of objects within the frame and the variations in brightness of a scene, which are not issues when you shoot using longer lenses.

3.1.1 Loads of Stuff in the Frame

Because a wide-angle lens captures a larger area than a telephoto, the subject suddenly has to compete with other objects for your viewer's attention. Using a telephoto, it is easy to get up close and suppress visual distractions, whereas a wide-angle might capture more than you bargained for, which can dilute the visual message. And it doesn't matter whether these additional objects are in front of, behind, or beside the main subject.

Exercise

Cut a four-inch square opening in a sheet of cardstock, shut one eye, and hold the card at arm's length in front of your face. Count the number of objects you can see through the hole. Now move the card closer and once again count the objects you can see. Congratulations! You have just simulated altering the angle of view in a zoom lens. Your outstretched arm represents the long end of the zoom range, while holding the card closer is like zooming in to the wide-angle setting. If you have ever watched people making movies, you will have seen how the director views a scene by holding the thumbs and index fingers of both hands up to form a rectangular "viewfinder." This has the same effect as the hole in your card and helps to visualize how a scene will look when shot at various focal lengths.

Figure 3-2: A finger-and-thumb "viewfinder" used to create a rectangle helps visualize the effects of varying focal lengths. The closer the rectangle is to your face the greater the simulated angle of view.

If you want to capture compelling wide-angle shots that don't look like snapshots, it is a good idea to alter your position instead of simply zooming in and out. Get up close, move around the subject, and keep an eye on the edges of the frame and the background while you shoot.

Every time I press the shutter button, I ask myself the following questions, and these are particularly important when I am using a wide-angle lens:

- Are there any objects that appear to emerge from the subject? Like the classic tree branch poking out behind a portrait subject's head or a horizon that coincides with the subject's eye level spring to mind.

- What's going on at the edges of the frame? Are any unwanted objects protruding into the frame?

Exercise

Pick a subject and move around it while you shoot. Get closer for some shots and move farther away for others, making sure you keep an eye on the objects at the edges of the frame and in the background. Capture shots from different perspectives and compare the results on your computer screen.

3.1.2 Lots of Contrast

Shooting with wide angles not only captures more content within the frame, it also increases the chance of capturing multiple details with varying brightnesses. This happens especially when shooting interiors. It is much easier to select a single, evenly lit detail with a telephoto lens than it is to use a wide-angle to capture an entire room, windows and all.

Figure 3-3: Using a focal length of 300mm and a correspondingly narrow angle of view, this shot shows an evenly lit detail.

Figure 3-4: The same scene shot with a 24mm lens includes a wide range of brightnesses. The range of contrast within the frame is much greater.

The dynamic range of a camera (i.e., the difference in brightness between the darkest and lightest details it can simultaneously reproduce in a single frame) is narrower than the dynamic range of the human eye. This results in scenes that show overexposed windows or underexposed interior details. Manufacturers are constantly improving the capabilities of their cameras, but there is still a long way to go before they are able to successfully capture a dimly lit interior and the sunny world outside in a single shot.

Interior photographers use a range of tricks to compensate for these limitations. High Dynamic Range (HDR) photography is probably the most widely used of these techniques. HDR uses software to merge a sequence of differently exposed shots into a single image that contains greater dynamic range than the camera could otherwise capture.

Like Moths Around a Flame

Aside from technical considerations, human perception once again plays a role in how one views an image. Bright details attract our attention more strongly than dark ones. If the main subject is located in a dark area, a bright window elsewhere in the frame can completely distract the viewer and weaken the overall effect of the image.

Generally speaking, wide-angle lenses require more care on the part of the photographer, both technically and creatively.

In this type of a situation, there are a number of questions you need to ask before you press the shutter button:

- How broad is the range of contrast within the frame?

- Does the planned image require additional artificial light (for example, when shooting an interior) to compensate for bright areas within the frame?

- Does it make sense to use alternative techniques (for example, HDR) to capture the planned image?

- Is it possible to reduce contrast by altering your position? A single step backward or to the side can make all the difference when it comes to mitigating distractingly bright details.

3.1.3 Big Backgrounds

The broader the angle of view, the greater the overall depth of field in the resulting image. Objects in the foreground appear disproportionately large, while distant details fade into the background. This effect is even stronger when you shoot using an ultra-wide-angle lens, and the difference between including too much foreground and too much background is often a delicate balancing act.

The obvious separation of foreground and background is one of the defining characteristics of wide-angle photography and is often used deliberately as a stylistic device. However, it can be tricky to get a grip

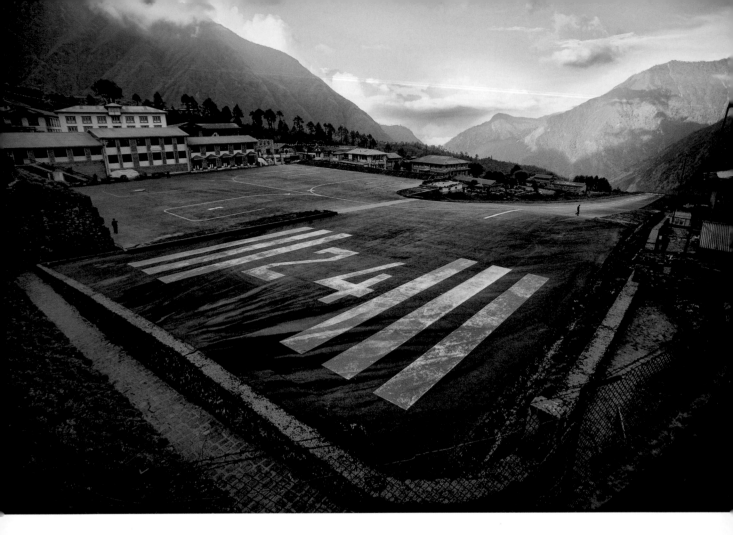

Figure 3-5: Runway, Lukla, Nepal
The 17mm lens gives strong
emphasis to the runway in the
foreground, which takes up half
of the frame. The people in the
image appear extremely small and
are reduced to being part of the
background, although they are in
fact only a few yards away.
(17mm, ISO 200, 1/100 sec., f/4)

on the unique depth effects that wide-angles produce, especially when you are just starting out.

If you don't get close enough, large portions of your subject matter can easily disappear into the background.

Questions to ask:

* How large do you want the subject to appear in the final image?

* What are the relative proportions of the main subject and the background?

3.1.4 Edge Distortion

Wide-angle lenses usually reproduce straight lines to look straight. However, wide-angle lens geometries make lines appear longer than they really are, and the effect increases toward the edges of the frame. This alters the visual proportions of the subject—an effect that works well in

Figure 3-6: Zoltán, the hatmaker's dummy, captured at the edge of the frame using a 100mm lens.

Figure 3-7: The same subject captured using a 24mm lens.

Figure 3-8: And this time with a 14mm lens.

an architectural context but one that makes familiar objects whose proportions we know look strange.

As discussed in chapter 1, circles and spheres captured using a wide-angle lens look increasingly oval the closer they are to the edge of the frame. The shorter the lens, the more we have to consider this effect when taking photos.

This issue is especially tricky when you are photographing people. If you use a wide-angle lens to capture a photo of a group of people that wouldn't otherwise fit into the frame, those at the edges of the frame will always end up with strangely shaped heads.

3.2 Separating Foreground and Background

Telephoto lenses make great photographic tools and are perfect for helping beginners capture their first successful images. Longer lenses capture less detail and make it easier to capture clear, well-composed images. The shallow depth of field produced by telephotos automatically creates a feeling of visual separation between the foreground and the background. Things get a lot trickier when you use a wide-angle lens.

Image composition involves attracting and holding your viewer's attention. Once you learn to use the necessary compositional tools, you can use them to guide a viewer's gaze and help her to explore the image. This is what great image composition is all about.

You need to pay special attention to the clear separation of important and less important details, which often equates to separating the foreground from the background. In other words, you want to separate the star of the show from the details that provide context and there are various ways to achieve this.

3.2.1 Using Depth of Field

Variations in sharpness help the viewer to distinguish between the main subject and the rest of an image. People usually classify objects that are in focus as more important than those that are blurred, and our eye naturally comes to rest on sharp details. We perceive blurred objects as belonging to a lower level and automatically treat them as visual "padding."

Telephoto lenses make separating the subject from the background easy, and the longer lenses normally used for portrait photography do this automatically. Wide-angle lenses behave differently, and the enormous depth of field they produce means you have to adjust your approach accordingly. This lack of spatial separation means you have to compose your images much more carefully, and it becomes essential to consider the effect of all the background detail in every shot.

Following are two basic ways to control depth of field in wide-angle shots:

- **Get closer:** reducing the distance between the camera and the plane of focus makes the background more blurred in relation to the subject. This is the only option if you are using a camera with a small sensor and a correspondingly short focal length. Try it out with your smartphone camera. Take a couple of shots from way up close and check out the effect this has on background sharpness.

- **Use a wide aperture:** the size of the aperture you select affects the depth of field in the resulting image, regardless of the type of lens you use. Unfortunately, the larger the maximum aperture (i.e., the brighter the lens), the more it will cost.

3.2.2 Using Contrast

Contrast, too, is a useful tool for separating the subject from the background. A bright subject in front of a dark background will usually command more attention than a bright subject in front of a bright background. A photo of a person with dark hair positioned in front of a dark background is difficult because their brightnesses are too similar. Dark hair will simply blend into a dark background and will have no visual effect in the image.

Obvious contrast between the foreground and background helps to keep the composition clean and emphasizes the subject in an image that has great depth of field.

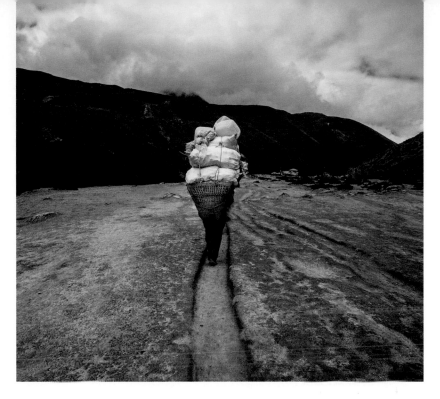

Figure 3-9: Inverse contrast: the brighter part of the subject contrasts with the dark part of the background and vice versa. (17mm, ISO 200, 1/1000 sec., f/4)

Experienced photographers instinctively look for a dark background when they are shooting bright subjects or a bright background for darker subjects. For subjects that contain both bright and dark areas, an effective trick is to use a background that inverts this relationship—in other words, positioning the brighter part of the subject to contrast with a darker part of the background (or vice versa).

The same is true of color contrast. If the color of the main subject is too similar to that of the background, you run the risk of losing your subject to the background. Complementary color pairs such as red/green and blue/yellow provide the strongest color contrast. More subtle tone-on-tone color contrasts can be effective, too, but only if the rest of the frame is rigorously composed and contains no distracting details.

Exercise

Look for a bright subject and capture it in front of both bright and dark backgrounds. Repeat the exercise with different colored subjects in front of different colored backgrounds.

Figure 3-10: Subtle lighting successfully separates the darker parts of the subject from the dark background. (50mm, ISO 400, 1/250 sec., f/4.5)

3.2.3 Using Lighting Effects

Another way to emphasize a dark subject in front of a dark background is to use lighting effects. Studio photographers often use a hair light or rim light positioned behind and slightly above the subject to produce a high-contrast edge.

If you keep a careful eye on the direction the ambient light comes from, you can create situations like this in the wild, too. For example, a deep archway will cast a shadow from above while allowing light to reach the subject from in front and from behind.

Exercise

Use a lamp to create a rim light for a dark subject in front of a dark background. There are bonus points for anyone who creates the same effect using only natural light, for example, from a window.

3.3 Proximity

Subject distance is a central theme in wide-angle photography. The optimal subject distance varies with the focal length of the lens you use, and the wider the angle of view, the closer you need to get to your subject to keep your composition clean.

3.3.1 Physical Closeness

The wider the angle of view, the more you can capture in a single frame. However, objects will appear smaller than they would if you use a longer lens. Having more stuff in the frame automatically alters the composition, so making sure you have an obvious subject helps to underscore a photo's message.

We have already looked at sharpness and brightness, and the way they emphasize the subject. In addition, the relative size of the subject is a significant factor in the way it is perceived. Quite simply, the more space the subject takes up within the frame, the greater its perceived visual importance.

Making a subject fill the frame is easy with a telephoto lens. In contrast, when using a wide-angle from the same distance, the subject tends to get lost among the background elements. To make up for this, you need to get closer to the subject, which will ensure it is the star of the composition. This simple trick allows the subject to fill the frame while keeping other details firmly in the background. It might sound paradoxical, but this is why short focal lengths often lead to the subject appearing larger in the final image.

Exercise

Use your widest-angle lens (either a prime or your widest zoom setting). Select a subject and capture it so that it fills the frame while remaining in focus.

Now shoot five more images, increasing the distance to the subject each time. Check your images on the camera's display and note the relative sizes of the subject and background detail in each image.

With a short lens the subject will appear quite small, even when it is still relatively close to the camera.

3.3.2 Metaphorical Closeness

Aside from physical proximity, there are other ways to get closer to a subject, too. Magnum photographer Robert Capa once said, "If your pictures aren't good enough, you're not close enough." Although this often gets interpreted as physical proximity, it is possible that Capa also meant an emotional closeness in regard to the subject matter of the picture.

This is especially true when the subject is a person. We humans have a kind of built-in "safe distance" when we interact with other people, especially in the case of those we don't know well. This safety zone can vary depending on the cultural norms of the society in question, and is only rarely deliberately encroached upon—for example, in elevators.

Because a wide-angle lens forces you to get closer to your subject, it will continually compel you to get inside the safety zone. This implicit physical closeness then automatically produces more emotional closeness.

The difference between a paparazzi shot captured from a safe distance using a long lens and a wide-angle shot captured up close is immediately obvious to the viewer, particularly with respect to the depth of field and the proportions in the image. Because it forces us to enter the "taboo zone," a wide-angle lens produces a feeling of closeness that is often absent with a telephoto.

Figure 3-11: Timket Festival, Lalibela, Ethiopia
The short 24mm focal length forces the photographer to get close to the subject and puts the viewer at the heart of the action.
(24mm, ISO 400, 1/4000 sec., f/6.3)

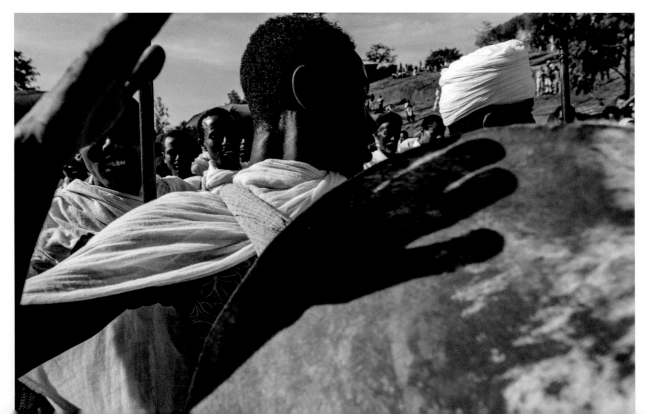

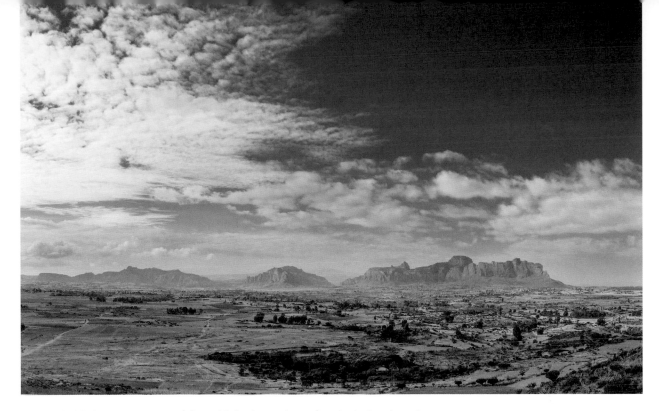

Figure 3-12: Images captured from high viewpoints often lack depth and end up looking two-dimensional. (24mm, ISO 200, 1/320 sec., f/5.6)

3.4 Creating Depth

When was the last time you photographed a land-scape from a high viewpoint? This type of shot often ends up looking lifeless and two-dimensional, with little of the dynamism of the actual scene. I seldom view shots like this a second time.

Many of the indicators we recognize in images captured using longer lenses are missing in wide-angle shots. Let's take a look at some ways to produce depth in wide-angle photos.

Figure 3-13: Lofoten, Norway
(24mm, ISO 400, 1/4000 sec., f/6.3)

3.4.1 Using Layers

Landscape photos are often in sharp focus, right from the closest foreground elements to the distant background. This makes it difficult to steer the viewer's gaze by relying solely on depth-of-field, and makes it impossible to identify the main subject through sharpness alone.

One popular way to preserve the three-dimensional feel in an image is to position the contents of the image on clearly visible "layers" of depth. Landscape photographers frequently use this technique and, even if the landscape itself is the most important element in the image, great landscape photographers always manage to produce a clear division between foreground, middle distance, and background details.

Most landscape images follow the same pattern of depth from near to far, and this is nearly always reflected in the distribution of detail from bottom to top in the resulting two-dimensional image. In other words, the foreground is at the bottom of the frame, the middle distance in the center, and the background at the top.

Figure 3-14: The distribution of depth in this image divides it into lower, center, and upper portions that correspond to the foreground, middle distance, and background.

Not all landscapes provide you with a convenient foreground object. However, lowering your viewpoint can turn an otherwise unspectacular patch of gravel or stretch of water into a kind of visual landing strip that immediately channels the viewer's gaze. You will often find landscape photographers working in awkward kneeling or lying positions with their tripod's legs spread wide or tilted wildly.

Figure 3-15: Here, the photographer has deliberately chosen a low viewpoint, giving the image an interesting and unusual feel. This makes the foreground broader and gives it more emphasis. (See the two-page-spread picture at the beginning of this chapter.)

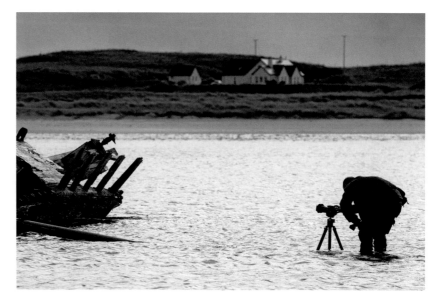

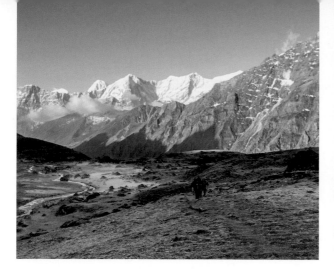

Figure 3-16: This image lacks foreground detail and is not especially interesting.
(24mm, ISO 200, 1/125 sec., f/6.3)

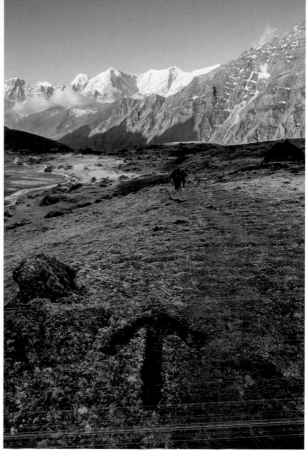

Figure 3-17: The inclusion of a foreground element guides the viewer into the image and adds a feeling of greater depth.

3.1.2 Using the Foreground

When it comes to creating successful images, many photographers agree that a simple foreground detail can be just as effective as a complex layered composition.

An object in the foreground fills the following roles:

* It gives the viewer a starting point from which to explore the image. I call this a visual landing strip.

* It stabilizes the image visually and gives the viewer a resting point from which to start investigating.

* It provides visual balance between the foreground and the background.

And don't forget, an object in the foreground can also serve to cover up other unwanted objects—for example, an unsightly outbuilding or a utility pole that would be difficult to edit out later.

Figure 3-18: Wide-angle lenses
emphasize the lines that accen-
tuate perspective and guide the
viewer into the image.
(14mm, ISO 100, 1/125 sec., f/11)

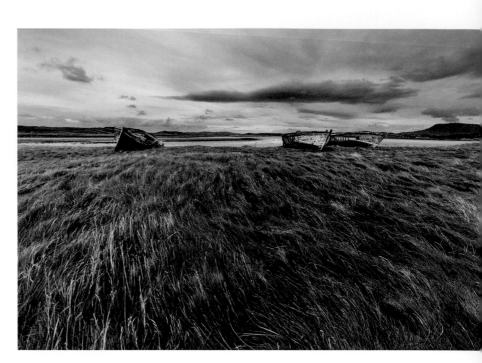

3.4.3 Using Lines

From fence posts to the lines created by the edges of a building, virtually any object can be used to guide the viewer's gaze. The shorter your lens, the more accentuated the effect of lines will be and the more you can leave attracting the viewer's attention and the creation of visual depth to the lines in the subject.

3.4.4 Using Contrast

In landscape scenes, contrast diminishes with increasing distance. This is particularly obvious in mountain landscapes in which receding rows of peaks fade away into the distance. In other words, high-contrast backgrounds influence the effect an image has on its viewer.

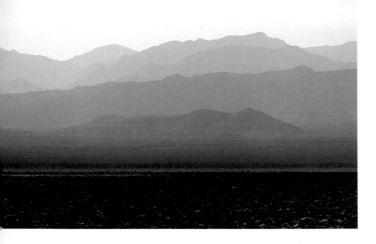

Figure 3-19: Contrast diminishes with increasing distance.
(300mm, ISO 400, 1/6400 sec., f/7.1)

3.4.5 Using Color

Color, too, can affect our perception of depth. The foreground of a landscape is often made up of warmer colors than the background and, the farther you look into the distance, the more diffuse blue light you will find. A warm foreground combined with a cool background accentuates the feeling of depth in an image.

The blue components of light are scattered by particles in the atmosphere, so the farther away an object is, the greater the diffusion. This effect—called *Rayleigh scattering*—is what makes the sky appear blue. The farther away a range of mountains is, the bluer it will appear.

Figure 3-20: Donegal, Ireland
The foreground is made up of much warmer colors than the distant mountains in the background.
(24mm, ISO 100, 1/160 sec., f/13)

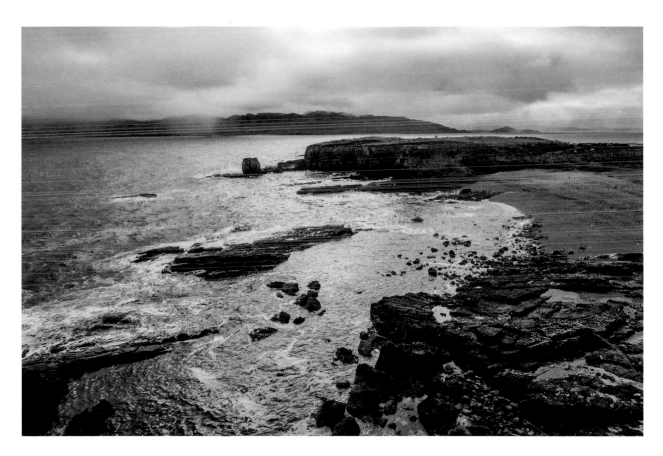

3.4.6 Using Content

The viewer knows instinctively how large most of the objects in an image are and how their various sizes relate to one another. Humans use this built-in ability, among other things, to judge depth, so a strategically placed person makes a great reference point within a composition.

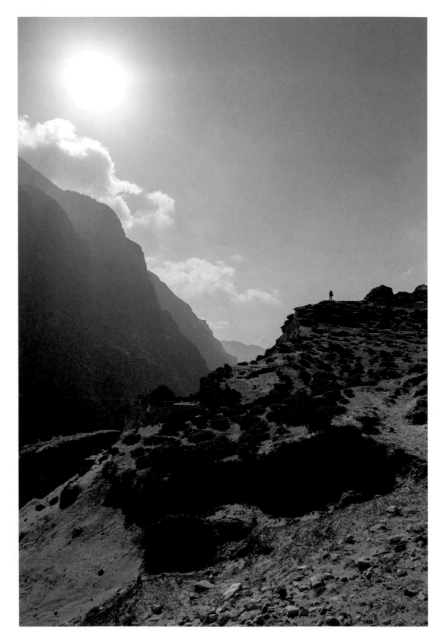

Figure 3-21: Because we know how large people are, a person in an image provides a reference for the size and scope of a scene. (24mm, ISO 400, 1/4000 sec., f/5.6)

3.4.7 Using Motion Blur

Motion blur is a more unusual device for indicating depth. Motion blur occurs when either the camera or its surroundings move during the exposure. For example, if you are shooting through the window of a moving vehicle, the sideways movement makes your speed relative to the foreground greater than it is to the background. Used with an appropriate exposure time, this so-called parallax effect [4] creates greater motion blur in the foreground than in the background.

Figure 3-22: The faster the sideways movement . . .

Figure 3-23: . . . the greater the contrast . . .

Figure 3-24: . . . between the foreground and the background.

3.5 Exaggeration

Normal lenses are called *normal* because they reproduce detail in a way that most closely represents the way the human eye sees things. However, as discussed earlier, this refers only to the depiction of depth and not to the angle of view. Many photographers prefer normal lenses in a range of situations because they don't exaggerate.

The legendary photographer Henri Cartier-Bresson, who often used a 50mm lens for his reportage work, said the following about wider-angle 35mm lenses in a 2013 interview with the *New York Times* [5]:

> ". . . very often, it is used by people who want to shout. Because you have a distortion, you have somebody in the foreground and it gives an effect. But I don't like effects. There is something aggressive, and I don't like that. Because when you shout, it is usually because you are short of arguments."

In other words: wide-angles exaggerate everything.

3.5.1 Depth

Visual exaggeration in an image increases with the angle of view of the lens. This effect is particularly obvious in the way wide-angle lenses reproduce proportions relative to distance from the camera. An object that makes a great subject using a 50mm lens appears so small when you use a 24mm that it simply disappears into the background. As a result, you have to change your viewpoint and get closer. This makes the object appear larger without altering the background too much, and the difference in scale between foreground and background is increased.

The deeper we delve into the wide-angle world, the more pronounced these effects become. For example, using an 8mm fisheye lens you can capture a portrait so that the subject's nose almost entirely fills the frame while the ears appear as a tiny, insignificant background detail.

3.5.2 Lines

These exaggerated proportions are also visible in the individual lines in an image and, once again, the solution is to get closer to accentuate the difference in size between foreground and background objects. This distance between parallel lines is thus visually increased, too.

Shooting from close up alters the way converging lines are reproduced, increasing the apparent angle between them and thus emphasizing their effect as they converge into the distance.

Chapter 4
Wide-Angle Lenses
in Practice

When seeing the words *wide angle* most photographers think about landscape and architectural scenes since both genres depend on capturing maximum breadth and depth. This chapter looks at wide-angle lenses in this context, but it also takes a broader view and includes a section on using these lenses for street photography and human subjects. Unjustly, portrait photography and wide-angle lenses are often considered to be mutually exclusive.

4.1 Landscapes

Many photographers dream about capturing exotic landscapes in compelling images. The images that fill the pages of the best travel books and magazines tell an unambiguous visual story of depth and breadth. Many photographers end up acquiring ultra-wide-angle lenses in the hope of producing similar results. This chapter investigates the wisdom of purchasing new equipment to solve problems that can often be addressed by rethinking what you already own.

4.1.1 Essentials

How Wide Does the Angle Need to Be?

How much of a wide angle do I need for the Grand Canyon? Is less (focal length) more? As with so many questions, the answers depend on a variety of factors. In chapter 2, we learned that a pair of human eyes covers an angle of view of about 180 degrees but sees depth in a similar way to a 50mm normal lens, with its narrower 40 to 50-degree angle of view. The tendency to grab a wide-angle to capture broad scenes often works out badly because wide-angles exaggerate depth, causing the middle ground to disappear into the distance. This effect can make majestic-looking mountains a lot less impressive in a photo than we remember them in real life.

This exact thing happened to me a few years ago on the highest mountain on Earth. At the end of a long journey, my companions and I wanted to grab a shot of our group with Mount Everest towering in the background. Our first few attempts at using a 16-35mm zoom to capture the depth and breadth of the scene along with the majesty of the mountain failed miserably. What we could see of the mountain was minimal and we were only able to capture the view in a way that barely approached how we saw it using a 50mm lens.

The difference between the way humans and wide-angle lenses see the world is so great that too short a lens often makes monumental objects appear tiny and insignificant in a photo.

You will by now have noticed that a large number of the images printed in this book were captured using a 24mm lens mounted on a full-frame camera. I like the balance between breadth and moderately exaggerated depth this lens produces. It has a sufficiently wide angle of view to capture magnificent landscapes and architecture while still retaining plenty of middle-distance detail. However, as you can see in figure 4-2, even a 24mm is often too wide.

Figure 4-2: Mount Everest. Any wider and the tallest mountain on Earth would become almost completely invisible. Mt. Everest, Jon Miller, Monika Andrae, Chris Marquardt (from left to right). (47mm, ISO 200, 1/250 sec., f/13)

The Right Viewpoint

Once you leave the realm of normal lenses, you need to adjust your viewpoint accordingly. You will have to take a few steps back when you use a telephoto, while wider lenses require you to get a lot closer to your subject. Each focal length speaks its own visual language.

📷 Opposite:
Figure 4-3: Using a wide-angle lens helps to simultaneously accent the foreground, middle ground, and background.
(24mm, ISO 100, 1/200 sec., f/14)

To get to know the attributes of different focal lengths, try out the following exercise: instead of grabbing your favorite zoom, leave the house for the day, the weekend, or even for a weeklong vacation with just your wide-angle lens. This might sound terribly restricting, but is guaranteed to get you past a steep learning curve. Of course, you won't be able to capture all the images you would like to, but I promise you, there is no better way to come to grips with a prime lens.

Once you have spent a week using only a 24mm lens, you will instinctively know which situations it is best for. Furthermore, leaving your comfort zone every now and again is a great way to give yourself a creative boost, as you will have to stretch yourself (sometimes literally) to get the images you want.

Try it out and analyze which viewpoints work best and why. If you repeat this exercise with various lenses, you will quickly learn which focal length delivers the best result in any situation.

Foreground, Middle Ground, and Background

The aim of taking photos is to trigger emotions. Ideally, someone viewing your photos should feel the same way you did when you pressed the shutter button. Landscape photographers often try to create this sense of excitement using the mantra-like formula "Foreground, middle ground, background."

A prominently positioned, in-focus foreground object with an interesting shape and good contrast grabs the viewer's attention and offers an irresistible jumping-off point for further investigation. The viewer then instinctively checks out the middle ground (which often contains some relevant detail but sometimes simply adds color contrast) before exploring the background. Clouds or unusual lighting effects in the sky round out the experience, but the main subject in the foreground remains the initial point of focus the viewer can return to as often as necessary.

A prominent close-up element can also create visual balance between the foreground and the background. Captured using a wide-angle, a small tree in the foreground can take up more space within the frame than an entire range of mountains in the background.

4.1.2 Other Tricks

Reflections

Reflections are an indispensable part of many landscape images, and even a small puddle can help to make a landscape photo more appealing. A reflection creates a feeling of symmetry and can itself be a point of interest. As we have already seen, landscape images are mostly composed with foreground, middle ground, and background elements arranged from bottom to top within the frame. Including a reflection in the foreground turns this pattern on its head by placing the most distant element (i.e., the sky) foremost in the frame where the closest objects are normally found. Playing with visual expectations like this is a sure-fire way of grabbing your viewer's attention.

Any body of water will do, whether it is a puddle, a rock pool, or a lake. The less the surface of the water is rippled by wind or other disturbances, the clearer the reflection will be. A puddle with a dark bottom will increase the contrast in the reflection it produces.

Because puddles are a lot smaller than a body of open water, their surfaces are usually calmer, thus increasing your chances of capturing a smooth reflection.

Figure 4-4: Reflections in a rock pool surprise our visual expectations by making the sky a part of the foreground. (24mm, ISO 100, 15 sec., f/8)

Figure 4-5: This behind-the-scenes shot shows just how small the "pools" really are. Choosing a low viewpoint is a great way to make the most of reflections on water.

Figure 4-6: This reflection in a puddle has been flipped on its head. This places what we would normally see as the foreground where we expect the sky to be.
(24mm, ISO 200, 1/640 sec., f/4.5)

Take a photo of a reflection and then flip it 180 degrees. Admittedly, you won't be the first person to try this, but a viewer can surely be surprised by the effect.

Switching Focal Lengths

Landscape photography doesn't always mean using a wide-angle. Isolating individual details in a landscape can be just as rewarding as looking at them as part of the whole. Viewed separately from their surroundings, specific details can have a more powerful effect than they have as part of a broader composition.

You can still create depth effects using a telephoto lens—for example, in a photo of a mountain range, the contrast diminishes with increasing distance and the farthest peaks appear pale and almost abstract.

Longer lenses help to mask unwanted objects, such as utility poles, that otherwise spoil the composition of a landscape image.

Exercise

Take "photos" without a camera. Look out the window and use your inner eye to conjure variously sized picture frames around what you see. The smaller your frame, the further you have effectively zoomed in.

Figure 4-7: Receding mountains in haze. (300mm, ISO 400, 1/1250 sec., f/5.6)

Panoramas

Shooting panoramas is an increasingly popular approach to landscape photography. The basic principle of capturing a panoramic image involves taking multiple photos of a scene and using specialized software to stitch them together into a single image. We will go into technical detail on how to do this in section 5.8. For now, we are going to concentrate on the compositional aspects of panoramas.

The ability to stitch multiple images together means you can extend your angle of view as far as you like, and modern software makes capturing even 360-degree images a snap. Panoramic techniques make conventional aspect ratios such as 4:3, 3:2, or 16:9 a thing of the past and catapult us into the realm of 10:1, or even wider.

Nevertheless, when shooting panoramas you still have to consider the same factors as when composing conventional wide-angle images. The huge angle of view means that individual details appear relatively small in the final image, and you need to take special care with layering effects. A prominent foreground element often contributes to the success of a panoramic image.

Figure 4-8: Displaying panoramic images requires plenty of horizontal space, so, though a smartphone may be able to capture panoramas, it isn't really the best tool for the job of showing them.

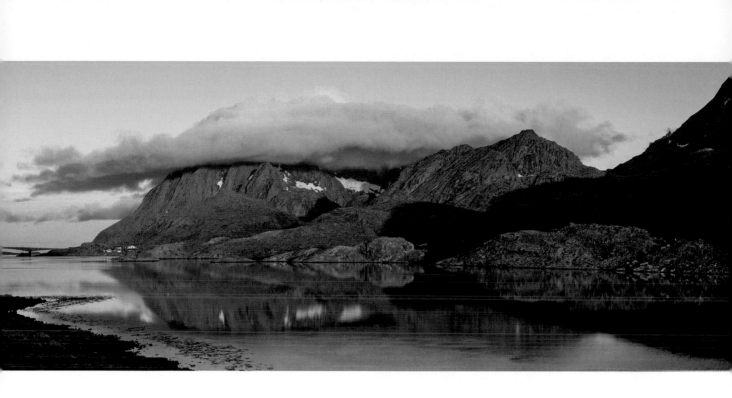

It is important to plan the final format of a panorama before you shoot. A 10:1 image will look pretty small when viewed on a 19-inch computer screen, and you would have to zoom in to properly view the individual details. A panoramic image viewed on a smartphone held in the normal, vertical position looks more like a colorful line than a photograph.

Panoramas really come into their own in print, and, if you have a roll-paper printer, there is no limit to the games you can play. A high-resolution panorama printed out and hung on a wall is spectacular to behold.

Figure 4-9: Midnight sun, Lofoten, Norway
A panorama created using 10 separate source images shot using a 70mm focal length.

Exercise

A panorama doesn't always have to be super-wide. Use a smart-phone with built-in panorama functionality to shoot multiple panoramas of a single scene. Always start in the same place, but rotate different distances for each panorama and compare the results.

Hiding in the Foreground

Wide angles capture lots of detail. However, this means you will often end up capturing things you don't want or simply didn't notice when you pressed the shutter button. When you view your images later, you may find a car driving past a range of mountains or a footpath snaking its way through an otherwise pristine landscape. It is always easier to avoid capturing unwanted objects than it is to clone them out later.

The best approach is simply to hide any objects you don't want to capture using the ones you do. The close-up shots that wide-angle lenses allow makes this simple to do, and you can use relatively small, nearby objects to block out much larger objects in the middle ground and background. Often, just a plant or a stone will suffice.

Figure 4-10: The waste bins and the utility pole spoil this otherwise idyllic scene. (24mm, ISO 320, 1/640 sec., f/7.1)

Figure 4-11: A slight change of position conveniently hides the unwanted elements behind a tree branch in the foreground.

4.1.3 Examples

By the Sea

Shooting by the sea is perpetually exciting and always has something new to offer. The water is constantly in motion and looks different every time a wave hits the shore. Shells are washed up, footprints create paths in the sand for your eye to follow, and the clouds reflected in the foreground create ever-changing colored accents.

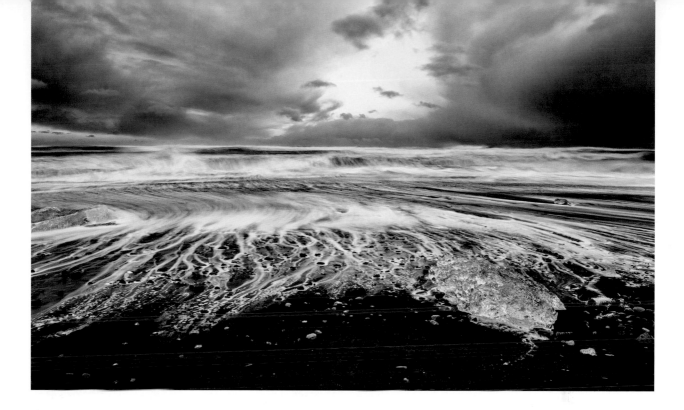

Maritime scenes are perfect for creative photography. Long exposures captured using a tripod create blur to illustrate movements in the waves or the clouds that can't be seen with the naked eye. The constant movement of the water means the distance between the photographer and the subject changes continually, so a wide-angle lens with its great depth of field is perfect for photographic experiments on the beach.

Gray Filters

One way you can take long exposures in daylight is to use a neutral-density (ND) filter [6], which works like sunglasses for your camera. They reduce the amount of light entering the lens without altering the colors too much. A strong ND filter allows you to set long exposure times you would otherwise use only at night, enabling you, for example, to create blur effects in moving water.

Always use a tripod to keep the camera stable during long exposures. If you are shooting in daylight, a 10-stop ND filter is fine for your initial experiments.

Figure 4-12: Lava beach, Iceland
The stark contrast between the white foam in the water and the black lava sand, combined with the closeness of the beach, strongly accentuates the entire foreground. The long exposure time highlights the movement of the waves. (24mm, ISO 100, 2.5 sec., f/7.1)

Here is a sample calculation when using an ND filter:

- The correct metered exposure in daylight at ISO 200 is 1/3200 sec. and f/4.

- A 10-stop ND filter thus lengthens the exposure time to 1/3 sec.

Number of f-stops	0	1	2	3	4	5	6	7	8	9	10	11	12	13	14
Exposure time (in seconds)	1/3200	1/1600	1/800	1/400	1/200	1/100	1/50	1/25	1/13	1/6	1/3	0.6	1.3	2.5	5

Table 4-1: This table lists the increase in exposure time produced by ND filters of increasing strength based on a metered exposure time of 1/3200 sec.

Because the metered exposure gave us an aperture setting of f/4, there is enough headroom to increase the exposure time by altering the aperture. If you want to reduce the exposure time, always increase the ISO setting.

Choose a time of day with interesting light—for example, the so-called *golden hour* just after sunrise or shortly before sunset—and look for an interesting foreground subject on the beach: this can be a stone, a trail of footprints, shells, or other flotsam. Sometimes the beach itself is interesting enough to make a good subject.

Now all you need is patience. Try capturing specific movements in the waves using exposure times between ¼ second and 1 to 2 minutes. And don't worry about producing junk—shooting a randomly moving subject like the sea always means capturing a whole lot of rejects.

Here too, your wide-angle lens will force you to get up close to your subject. On the beach, this may mean that your tripod's legs will get wet. Wellington boots for your feet (and perhaps your tripod, too) will prevent you from having to run from your prime position every time a wave comes in, and a spare toothbrush is a great tool for scrubbing your tripod in the bathtub after a hard day's work.

Graduated Filters

Thanks to the wide angle of view, interesting cloud formations and the sky itself often play a prominent role in wide-angle photos. However, there is often a high degree of contrast between the sky and the fore-

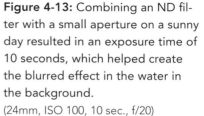

Figure 4-13: Combining an ND filter with a small aperture on a sunny day resulted in an exposure time of 10 seconds, which helped create the blurred effect in the water in the background.
(24mm, ISO 100, 10 sec., f/20)

ground. Landscape photographers often use HDR techniques to keep this effect in check. This involves capturing multiple shots of a scene using varying exposures and then merging them into a single image using custom software. This approach works well with stationary subjects, but is less suitable for constantly moving subjects such as the sea or a tree in the wind.

The ideal tool for this type of situation is a graduated filter, which enables you to darken the sky by several f-stops without affecting the brightness of the foreground. What such a filter actually does is adjust the effective brightness of the sky to within the camera's normal dynamic range, thus giving you much more room to maneuver at the editing stage.

Figure 4-14: Here, I used a 10-stop ND filter to increase the exposure time. This smoothed the surface of the water and accentuated the movement in the clouds. I also added a 3-stop graduated filter to darken the sky and increase the overall drama in the image.
(24mm, ISO 100, 20 sec., f/8)

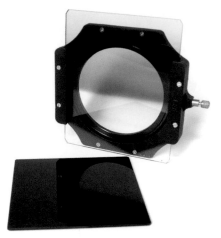

Graduated gray filters (also known ND grad filters) are available in a variety of strengths and with hard or soft transitions. Filters are usually sold as circular screw-in models or as square gels for use with a lens-mounted holder. Holder-based filter systems are more flexible and make it easy to adjust the height and angle of the transition.

In the Mountains

I find mountains fascinating, and I will never forget being surrounded by 26,000-foot peaks during a trek in the Himalayas. The sheer size and overwhelming impact of this type of landscape imprints itself indelibly in one's memory, and capturing this immensity in a photo is a real challenge. Even though it seems like a no-brainer to use a wide-angle lens in this type of situation, the wide angle of view can easily make even the largest mountain appear small and insignificant.

Here are two ways to counteract this problem:

1. Practice shooting with varying focal lengths in advance of your trip. A moderate wide-angle is often preferable to an ultra-wide-angle in this type of situation.

2. Remember to include reference objects in your composition such as a person or a manmade object.

We intuitively know the size of people, buildings, and cars. I used to try hard to avoid capturing these kinds of extraneous objects in my images, but I now know it is essential to include them as references so the viewer can get a sense of the scale of a scene.

Figure 4-15: A filter holder shown with a graduated filter mounted in it, with a 10-stop ND filter along side it.

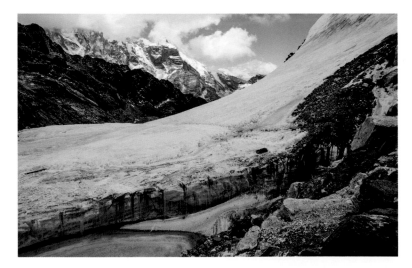

Contrast

Using a wide-angle lens in the mountains usually means you will have to deal with a lot of contrast. While you can simply leave the sky out of the

Figure 4-16: Without people as a reference (see figure 4-17) it is impossible to guess the true scale of the subject, and the photo loses its impact as a result.

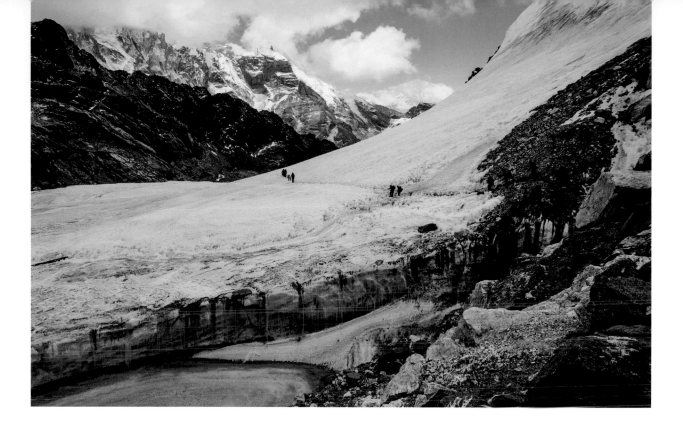

frame using a telephoto, it is virtually impossible to avoid capturing it when you use a wide-angle. In the mountains, the contrast between the foreground and the sky is usually quite high, especially in regions where the peaks block the sun and cast long shadows in the foreground.

The horizon in the mountains is never straight, making it impossible to effectively apply a graduated gray filter—unless of course you don't mind darkening some of the peaks, too.

Figure 4-17: The Cho La summit pass, Nepal
The people in the picture are essential to illustrating the grand scale of this scenery.
(24mm, ISO 200, 1/1000 sec., f/7.1)

In the Country

Mountains and oceans are the two most extreme landscape subjects. But what can you do if you go on vacation in the plain old countryside? Don't sweat it—even the remotest corners offer plenty of enticing photographic subjects.

Depth and breadth are important factors in landscape photos and, paradoxically, you can often see farther in uneven terrain than you can in the flats. Distant hills and mountains are often visible for miles, while the horizon in the prairie often begins at the next bush. This makes dividing the frame into foreground, middle ground, and background zones much trickier in the countryside, so you need to concentrate on other things if you want to breathe life into your landscapes.

Figure 4-18: The Danakil desert in Ethiopia isn't exactly cozy, however, the intriguing shapes and strong contrast in the foreground turn this otherwise minimalist composition into an enticing photo. The road leads the viewer's eye into the distance and invites you to get on board along with the travelers.

(24mm, ISO 200, 1/500 sec., f/7.1)

In this context, too, an interesting foreground nearly always helps pep up an image. Playing with geometry and lines are just two of the countless ways of grabbing your viewer's attention, and the foreground itself is often interesting enough to give an image impact.

In these kinds of landscapes, I often use a lot of sky in my compositions, sometimes even to the extent of reducing the landscape to a subsidiary detail and devoting most of the frame to the sky. Of course, this approach only works well if the clouds and the light are interesting enough to carry the image.

A flower meadow makes a great wide-angle foreground, while the wide angle of view includes enough background to provide context (see figure 4-20).

Figure 4-19: The striking clouds occupy most of the frame.

(24mm, ISO 200, 1/400 sec., f/8)

Figure 4-20: The focus is on the flowers in the foreground. Thanks to the 24mm lens combined with an aperture setting of f/8, the background provides some context. (24mm, ISO 200, 1/200 sec., f/8)

Reference Points

Scale references are not only useful in the mountain. Generally speaking, an image of an unfamiliar scene usually benefits from including one or two more familiar objects. In figure 4-22, the sheer size of the frozen lake only becomes apparent when we include a familiar object to measure against.

Figure 4-21: Lake Baikal, Siberia, frozen over. (70mm, ISO 200, 1/2500 sec., f/7 1)

Figure 4-22: Including these trucks in the composition reveals the true scale of the scene.

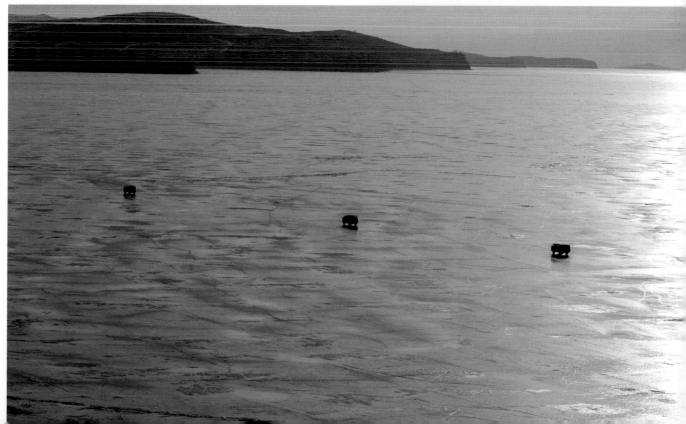

4.2 Architecture

Along with landscape photography, architectural photography is one of the most common applications for wide-angle lenses. Lines, angles, and surfaces, and the interplay between them, look much more dramatic when captured using a wide angle of view. A wide-angle is often essential if you want to capture an entire building in a single frame. This section addresses the benefits and drawbacks of using wide-angle lenses to photograph architecture.

4.2.1 Essentials

Straight-On Perspective

Figure 4-23: The Triumphal Arch, Moscow
The single-point perspective and the straight camera setup keep all the horizontal and vertical lines in this image parallel. They also emphasize the lines that point directly toward the subject and converge into the distance.
(24mm, ISO 200, 2 sec., f/11)

Architecture is defined by lines, edges, and surfaces that are arranged in three dimensions. As long as we are not talking about an old farmhouse, it is safe to assume that the lines in a building are either parallel or meet at precise angles. Your choice of focal length dictates how these lines are reproduced in a photo.

If you set up your camera in front a building so that it is parallel to the horizontal and vertical lines in the architecture, the resulting view is called single-point perspective. Architectural photographers are extremely conscious of parallel lines in their compositions, and the behavior of vertical lines is of particular importance in this context.

The walls of contemporary buildings are built with the help of spirit levels, so it makes sense to use a level to set up your camera. As long as the sensor is set up parallel to the front wall of the building, the lines in it will appear parallel in the final image.

Levels come in different shapes and sizes, like those you can attach directly to your camera's flash shoe. Many of today's cameras have a built-in digital level that you can superimpose on the display. Once the camera is set up, all you have to do is select the correct subject distance for your lens and press the shutter button. You now have your first single-point perspective shot in the bag.

Without a Level

If you don't have a level, use the grid in your camera's display to orientate your composition. If your camera doesn't have a grid function, line up the vertical lines in the subject with the left- and right-hand edges of the viewfinder or vertical lines in the surroundings instead. If the horizon is low, such as when looking out at sea, it is often sufficient to line it up horizontally through the center of the viewfinder—the rest of the frame will then take care of itself.

Figure 4-24: A viewfinder with the grid function switched on. The picture is level when the vertical lines of the grid are parallel to the vertical lines in the subject.

Vertical Lines

If you use a level to set up your camera, the horizon will always end up horizontal, whether or not you can actually see it. This is particularly obvious at the ocean, where you nearly always have a clear view of the horizon. Because the visible parts of buildings are usually located above the horizon, they often get cut off at the top of the frame.

To be sure of capturing the entire building, you can use one of the following strategies, which are explained below:

1. Tilt the camera.

2. Increase the angle of view.

3. Increase the subject distance.

4. Raise your viewpoint.

5. Use specialized gear.

Strategy #1: Tilt the Camera

Sometimes, the only way to capture an entire building is to tilt the camera upward. This helps to capture the subject but means that any parallel lines will converge toward the top of the frame. This spoils the composition and gives the viewer the impression that the building is tipping over backward, which is why this approach is seldom used by serious architectural photographers. Successful architectural images depend on clear compositions and parallel verticals.

Image-editing software offers a number of ways to correct converging lines, and some applications even offer one-click solutions.

One disadvantage of using software to correct converging lines is that you will lose some of the original pixels. Also, it sometimes tends to visually compress the rest of the image. Digital perspective correction resamples some of the pixels and creates new ones to fill any gaps. Today's high image resolutions and sophisticated editing algorithms have simplified things, but you still run the risk (albeit small) of creating unwanted artifacts when you use this approach.

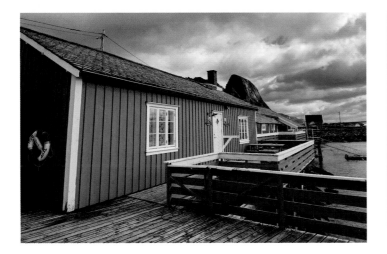

Figure 4-25: Tilting the camera means the vertical lines in the subject are no longer parallel.
(24mm, ISO 100, 1/320 sec., f/7.1)

Figure 4-26: In this case, I used image-editing software to restore order.

Back in the analog darkroom days, photographers counteracted converging lines by altering the angle between the enlarger head and the print plane, which are normally set up parallel to one another.

Strategy #2: Increase the Angle of View

To avoid having to tilt the camera, you can simply use a lens with a wider angle of view, which allows you to keep the camera parallel to the front of building. This approach might waste a bit of space in the lower portion of the frame but saves you from having to correct your image digitally later on. The upper portion of the frame contains the building without any converging lines, and all you have to do is crop it accordingly.

This approach means you don't have to guess how your subject will look after you have edited it. No editing also means no resampling and no loss of image quality. The downside of this approach is that cropping much of the image reduces overall resolution and, of course, there would be the additional cost for a wider-angle lens.

Strategy #3: Increase the Subject Distance

If there is room, moving farther away from the subject also helps to keep the camera parallel to the subject and prevent converging lines from spoiling the image.

If you shoot from too far away using a wide-angle lens, you run the risk of the subject appearing too small in the final image, so it may help to use a longer lens instead. The downside of this approach is that it cuts out potentially valuable foreground detail.

Figure 4-27: Moscow skyscrapers captured using a medium telephoto lens from the 14th floor of a nearby building. The relatively large subject distance and the telephoto lens keep the vertical lines parallel but cut out large parts of the foreground. (70mm, ISO 400, 1/320 sec., f/5.6)

Strategy #4: Raise Your Viewpoint

Another way to avoid converging lines is to raise your viewpoint, either using natural features in the landscape or shooting from a nearby building (as I did for figure 4-27). British photographer Donovan Wylie used a helicopter to gain height when shooting a series of military watchtowers [7].

The price of this approach is the loss of foreground detail you would otherwise see at street level. You also have to gain access to a higher viewpoint, either by prearrangement or by asking strangers if you can use their premises.

Figure 4-28: Abandoned house, Isortoq, Greenland
Shot from a nearby hillock, the vertical lines remain parallel without additional editing.
(24mm, ISO 200, 1/400 sec., f/5)

Strategy #5: Using Specialized Gear

In the early days, architectural photographers used large-format cameras that have the inherent function of correcting perspective. This type of camera can be set up parallel to the front of a building and the framing can be altered without having to tilt the camera. This ensures that all parallel lines remain parallel in the resulting image.

With a shift lens, what you see is what you get.

Shift lenses are available for smaller cameras, too. These enable you to shift the lens axis in various directions without having to tilt the camera, thus keeping parallel lines in the subject parallel in the final image. If you use a shift lens carefully, you won't have to correct any converging lines and your image won't require any cropping.

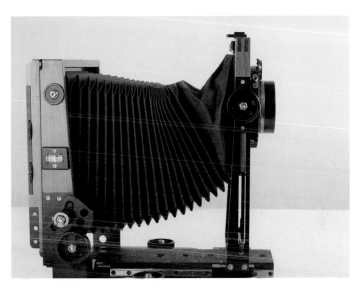

Figure 4-29: A large-format camera enables you to shift the lens without tilting the film plane. This ensures the image contains no unwanted converging lines.

There aren't many shift lenses available, and they often cost more than the camera body they are attached to. They require manual focusing and exposure metering, and you will need plenty of practice using one if you want to get the best possible results. (See chapters 6 and 7 for a detailed look at tilt-shift lenses.)

4.2.2 Other Tricks

Indoors and Outdoors

Indoor architectural shots aren't much different from outdoor shots. Converging lines are just as much of an issue, and images look much cleaner and more professional if the camera is set up to avoid them. Because indoor scenes involve less vertical space than outdoor scenes, you can alter the parallel perspective more easily using vertical changes in the camera position. Otherwise, the techniques for dealing with converging lines we discussed in the previous sections still apply. The main limitation for indoor scenes is that it is much more difficult to move farther away or to use longer lenses.

Figure 4-30: For this shot of a bicycle in a stairwell, I deliberately overexposed the windows to provide enough light for the rest of the frame.
(24mm, ISO 1600, 1/60 sec., f/4)

The biggest issue when shooting indoor scenes is lighting. Indoor scenes are usually much darker than outdoor scenes. You will often have to decide between deliberately overexposing the windows, or using HDR techniques, or using an additional artificial light source to illuminate your subject. See section 3.1.2 for more on this topic.

From an Angle

As soon as you move away from a central, single-point perspective and view the corner of a building from an angle, horizontal lines will appear to converge and will point toward two separate vanishing points on the left and right of the frame. Provided the camera's sensor is set up parallel to the vertical plane of the building, all vertical lines will remain parallel.

Figure 4-31: Monticchiello, Italy
Two-point perspective is easier to manage
than one-point perspective.
(24mm, ISO 800, 1/320 sec., f/5.6)

Figure 4-32: In this image, only the vertical
lines are parallel and the vanishing point is
right at the edge of the frame.

Deliberate or Accidental?

Tilting the camera is not taboo in architectural photography, provided it
is obvious that the effect is intentional. Slight tilt seldom appears delib-
erate, whereas a more exaggerated tilt makes it clear that this is what
the photographer intended. Try photographing a building from right up
close with your camera tilted steeply upward.

Figure 4-33: A steeply tilted
camera used up close speaks a
highly individual visual language.
The strongly converging lines
clearly illustrate that this was the
photographer's intention.
(17mm, ISO 400, 1/500 sec., f/4)

Figure 4-34: An unusual view of St. Basil's Cathedral in Moscow. Thanks to the large subject distance and a focal length of over 200mm, all the vertical lines remain parallel.
(220mm, ISO 200, 1/1600 sec., f/5)

4.2.3 Examples

Churches

Large churches and cathedrals are often built on squares, which allows you to photograph them from a distance using a longer lens, thus enabling you to keep control of any potentially converging vertical lines.

Using a wide-angle lens allows you to include more foreground detail while keeping the camera's sensor parallel to the front of the building.

Shooting from the interior is a great way to illustrate the scale of a cathedral. Try it out for yourself and include some people or other familiar objects that will provide a size reference. Correcting perspective digitally later on will help underscore the impact of the architecture.

Figure 4-35: Dormition Cathedral, Moscow
Because there wasn't sufficient space to use a 24mm lens to capture this shot without converging lines, I used a combination of lens shift (see chapter 6) and digital perspective correction (see figure 4-26).
(24mm, ISO 200, 1/1600 sec., f/5.6)

Figure 4-36: Freiburg Cathedral, Germany
Taken with a 4×5 large-format camera, this image
was captured with the lens board shifted upward
to ensure that the vertical lines remained parallel.
(65mm, ISO 400, 3 sec., f/22)

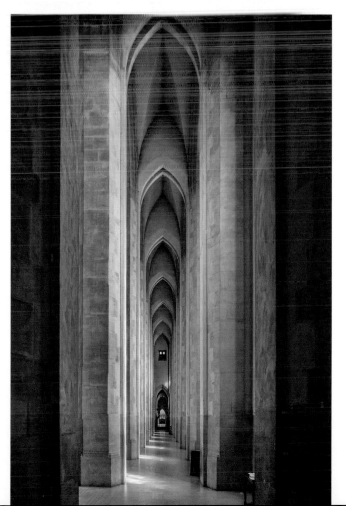

Figure 4-37: Farnborough Cathedral, England
Here, too, I shifted the lens and added some
digital perspective correction during the
post-processing stage.
(24mm, ISO 400, 1/60 sec., f/5)

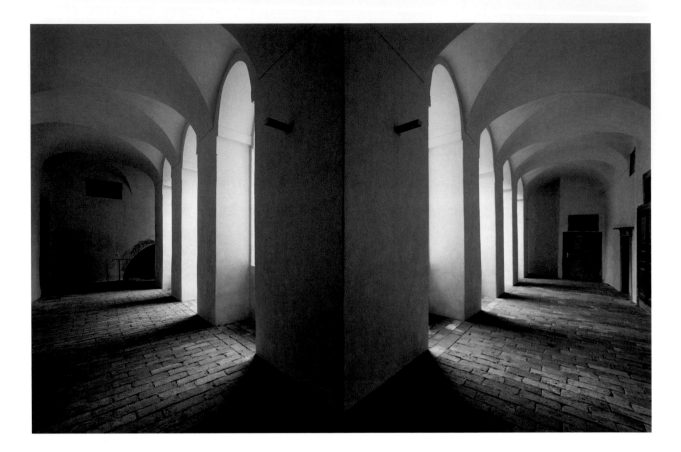

Figure 4-38: Cloisters, Inzigkofen Monastery, Germany
You can keep lines parallel without digital help if you shoot from an appropriate height. This image was captured from eye level. I had no spirit level with me, so I lined up the verticals with the grid on the viewfinder and with the edges of the frame.
(14mm, ISO 100, 1/200 sec., f/4)

Monasteries

Cloisters often appear quite radiant, especially when the sun is low in the sky. At these times of day, sunlight is reflected off multiple surfaces before it reaches the ground, providing a beautiful, soft luster that illuminates the columns and floods the walkways with diffuse light. This type of light is perfect for architectural photography and is well suited for portrait photography, too.

The parallel verticals in the columns offer plenty of opportunities for playing visual games with geometry, and the repeated shapes are perfect for experimenting with continuous and interrupted patterns. Using a strong wide-angle lens, you can use the camera position to keep the verticals parallel or deliberately let them converge to accentuate the height of the space. In this kind of situation, symmetrical compositions create a special kind of resonance.

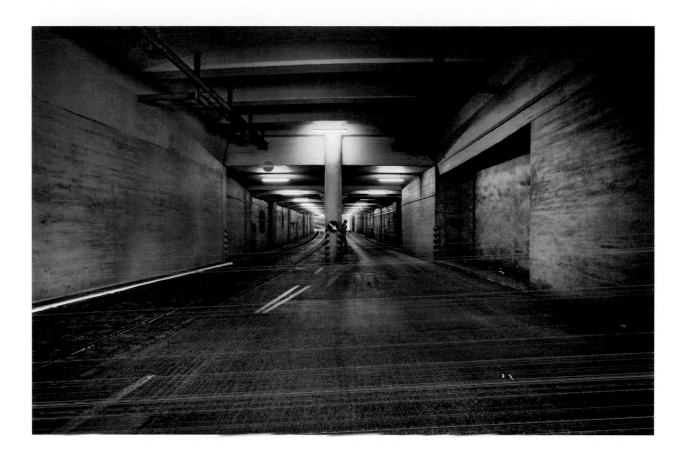

Tunnels

In this example, an extreme 17mm wide-angle lens produced a particularly distinct perspective effect. The converging lines lead you deep into the image and the road disappears into the unknown, giving the image an irresistible fascination. The lighting, too, helps to draw the viewer in toward the vanishing point. The figure close to the center of the frame (where the arrow is pointing) is so far away that it becomes a secondary background detail.

Figure 4-39: The 17mm lens I used produced a strong perspective effect.
(17mm, ISO 250, 1/20 sec., f/4)

4.3 Street Photography

The term *street photography* encompasses a number of subgenres. Some people use it to describe urban landscapes, while others use it to refer to spontaneous portraits. However, it is most widely used to describe situations in which the photographer remains unseen while capturing images of people in interesting or unusual situations. This section deals with the latter form.

Please note that different societies view taking photographs of strangers—whether openly or secretly—in different ways. A discussion on the morals of street photography is way beyond the scope of this book, but suffice it to say that you should always respect your subject and the according legal codes, wherever you happen to be.

4.3.1 Essentials

Choosing the Right Focal Length

You probably don't immediately associate wide-angle lenses with street photography. It is much easier to shoot undetected and avoid intruding on people's personal space using longer lenses.

But before we go into detail, I'd like to mention a more philosophical aspect of lens choice that is often overlooked. I will explain why I prefer to use short lenses in street photography situations.

The way depth is reproduced tells even an untrained viewer whether a photo was captured using a wide-angle or a telephoto lens, and thus whether the photographer was shooting at a safe distance or up close and personal. Not only do typical paparazzi shots captured with a 500mm lens from a safe distance have their own aesthetics, they also demonstrate the imbalance of power between the photographer and their subject. A person targeted with a long lens has little chance of avoiding, or even seeing, the photographer.

In contrast, wide-angle lenses provide more of a level playing field, and the shots they produce are simultaneously more powerful and authentic (see figure 4-40).

Finding Focus

As a street photographer you have to be fast, whether you shoot from the hip or with your eye glued to the viewfinder. You need to quickly recognize when an interesting situation develops and react swiftly in order to capture it successfully. Anything that slows you down could mean that you press the shutter button a moment too late.

Wide-angle lenses capture a lot of detail, and some of these details are bound to be more important than others—and sharpness is a critical indicator of importance in a photo. Autofocus is a great invention, but some cameras and lenses are not as fast as we would like them to be.

Autofocus in smaller cameras can also be a bit too slow for street shooting. Furthermore, the focus points that the camera automatically selects don't always know which is the most important detail. If you shoot from the hip using a wide-angle lens, you are sure to capture your subject, but you can't be certain it will be properly in focus.

Trap Focus

To counteract these issues, street photographers often use a technique called *trap focus*, although *zone focus* is probably a more accurate term. You don't actually set a trap; instead you set your camera to cover a predetermined zone of focus and lie in wait until your subject enters the area. You can then snap away without having to think about focus settings at all.

This is how it works:

1. Select a distance at which your subject will be reproduced at the desired size using the lens you have selected. For this example, let's assume you are using a full-frame camera with a 35mm lens set to f/8 and a distance of 6 feet.

2. Use a depth-of-field calculator to work out the zone of acceptable sharpness [8]. Our sample values give us a near limit of 4.44 feet and a far limit of 9.25 feet. In other words, everything between the near and far limits will be in focus.

3. Set the aperture, focus on an object that is 6 feet away, and then switch autofocus off. Your focus setting will remain set.

4. Now all you have to do is wait until your subject enters your preset focus zone and release the shutter.

This approach ensures that you capture your subject in focus, even if you are shooting from the hip.

Exercise

In addition to the focal length, the aperture setting and subject distance influence the degree of focus in the background. When you are out and about with your wide-angle, take regular test shots at varying distances using different aperture settings. This will help you to develop a feel for the results produced by each combination of values.

Figure 4-41: Union Square, San Francisco, California
In this street shot, the short lens produced plenty of depth while providing additional context for the main subject.
(24mm, ISO 400, 1/2500 sec., f/4)

Context and Aperture Settings

Street scenes come alive from context. The interplay between a subject and its surroundings is a crucial part of the visual storytelling process. Wide angles of view automatically bring more context into the frame. All elements (often the background) don't have to be in focus. Slightly blurred objects can remain recognizable and may offer visual support for the main subject.

Type and Direction of Light

Wide-angle lenses require you to pay close attention to your lighting. Wide angles of view capture a broad range of contrast, and this becomes particularly obvious when shooting in bright sunlight in the city. One side of the street could be bathed in dazzling bright light while the other side is in deep shade. These differences in brightness can be a help or a hindrance, depending on the situation.

Try it out for yourself: take some shots of a person who is in the shade in front of a brightly lit background.

Figure 4-42: This shaded figure in front of a well-lit surface produces a silhouette with no recognizable detail. (24mm, ISO 3200, 1/60 sec., f/3.5)

Apart from shooting at different times of day, there is nothing you can do to influence the direction of sunlight except change your position relative to your subject. The lighting in a street shot depends on which side of the street you are shooting from and from which direction you are shooting.

Subject position and direction have a strong influence on the look of an image (see figure 4-43).

1. Subject in the shade, background well lit = silhouette.

2. Subject in the shade, background in the shade = diffuse light throughout the frame.

3. Subject in backlight, background in the shade = diffuse overall lighting with a sharp subject edge light.

4. Subject lit from the front, background well lit = heavy shadows all around.

4.3.2 Other Tricks

A Flick of the Wrist

It is not always possible to compose spontaneous street shots using the viewfinder. Shooting literally *from-the-hip* is often the best solution, especially if you don't want to be seen. What gunslingers in a Western movie can do, you, too, can do with a wide-angle lens and a little practice. Wide-angles capture a broad view and help to ensure that you capture your intended subject, even if you don't have time to aim properly. You are sure to produce quite a lot of wasted shots when you are first starting out, but, with a little practice, you will soon begin to capture unusual shots from unconventional angles that you wouldn't normally have considered.

If you aren't successful right away, practice by shooting photos of yourself reflected in a storefront window. You can check the results in the camera display and refine your shooting technique until you get it just right.

4.3.3 Examples

Street Scenes with Buildings

The biggest challenge in street photography is striking the right compromise between foreground and background detail. Streets are full of signs, storefronts, buildings, pipes, and cables. Moving cars don't make the job any easier, and a perfect composition can be instantly ruined by a truck pulling up.

Figure 4-43: The direction of the sunlight and the subject's location are important factors that determine the look of street photos.

Photos that don't have a human subject are defined by lines, lighting, and the interplay of geometric shapes. Here, too, your photos will turn out better if they have an obvious main subject.

To make sure you don't capture too many objects that get in each other's way, try the following:

- Shoot from a low standpoint. This draws attention to the foreground and emphasizes the details that are closer to the camera.

- A low viewpoint combined with a backward-tilted camera can completely hide the foreground.

- Shooting from very close with a short lens makes the subject appear disproportionately large and relegates a busy background to the role of contextual detail.

- When shooting on city streets, always consider the direction the light is coming from. Depending on the time of day, different parts of the scene will be in the shade, while others will be brightly lit. Reflections from glass frontage often add exciting spontaneous detail.

Apps like Sun Surveyor and The Photographer's Ephemeris enable you to accurately predict the angle and position of the Sun and Moon anywhere

📷 Opposite:
Figure 4-44: Taxi, New York City. The bright color and the proximity of the taxi in the foreground make it a doubly important feature. For this shot, I used a 24mm tilt-shift lens to correct the perspective and hide the foreground.
(24mm, ISO 400, 1/160 sec., f/7.1)

Figure 4-45: Facade, New York City
The sun shines along the direction of the street, producing long shadows and interesting reflections off a hotel marquee and on the skyscraper in the background.
(24mm, ISO 400, 1/160 sec., f/7.1)

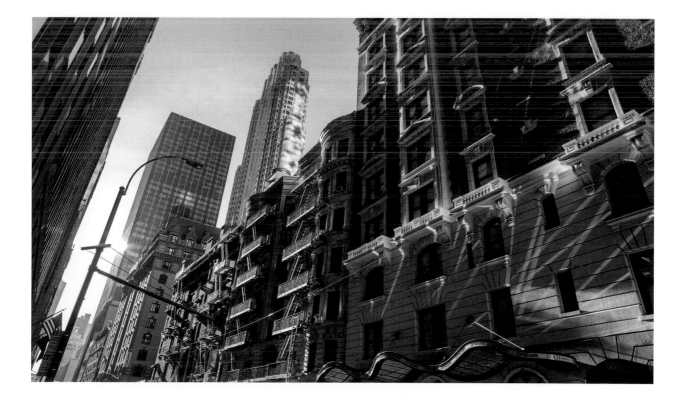

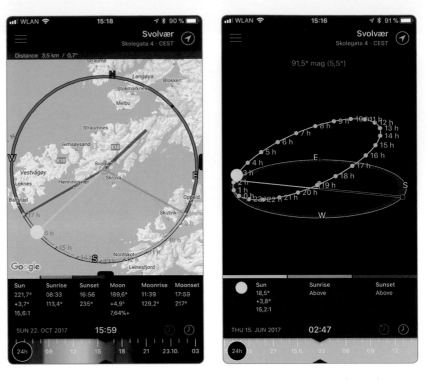

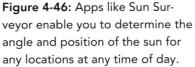

Figure 4-46: Apps like Sun Surveyor enable you to determine the angle and position of the sun for any locations at any time of day.

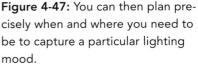

Figure 4-47: You can then plan precisely when and where you need to be to capture a particular lighting mood.

in the world. Photographers use apps like these to plan shoots of phenomena such as *Manhattanhenge* [9], where the sun shines directly along the east-west facing streets of Manhattan.

Street Scenes with People

People are a wonderful part of many street shots, either as the main subject or as part of the scenery. Cityscapes are dominated by the formal geometrical shapes of buildings, so the organic form of a person makes a great device for mixing up a scene and adding a nontechnical counterpoint.

Faces, eyes, and the shape of a human body act as visual magnets that automatically attract a viewer's attention. If you don't want to photograph strangers, there are always plenty of signs and posters depicting people that you can use as a substitute. These types of images are also great for playing visual games—for example, with the contrast between large and small, real and fictional, or weak and strong (see figure 4-48).

Parts of People

Sometimes you only need to capture part of a person to create a compelling image (see examples on opposite page).

Figure 4-48: *Atlas*, La Jolla, California
The graffiti on the bridge support immediately grabs your attention, and it is only when you take a careful second look that you discover the real person in this shot. (24mm, ISO 200, 1/160 sec., f/5.6)

Figure 4-49: New York
The feet in this shot add a human element and help the viewer to judge the scale of the subject. (14mm, ISO 100, 1/200 sec., f/4.5)

Figure 4-50: Central Park Reflections
The people in this shot form silhouettes against the bright reflection of the sky. (24mm, ISO 400, 1/160 sec., f/4)

Camping

The *camping* method is a great way to capture photos in streets with a lot of people. Often used by Henri Cartier-Bresson, this technique involves finding an interesting location where you can stay put for a while and compose an image around a person who has not yet arrived on the scene. Once you have set up your shot, all you have to do is wait for someone to enter the frame and complete the picture.

Figure 4-51: Phones, New York City
The diffuse light in this scene provides even foreground and background illumination, and emphasizes the real/fake human content of the image.
(24mm, ISO 400, 1/200 sec., f/5)

Street Scenes with People and Animals

If you don't feel comfortable speaking to strangers, try approaching them via their pets. "Isn't he cute, may I take a photo of him?" nearly always works as an opener. No one has ever refused me when using this approach and once you have a shot of the pet in the bag, it is easy to get talking and ask for permission to take a picture of the owner, too. Try it out for yourself!

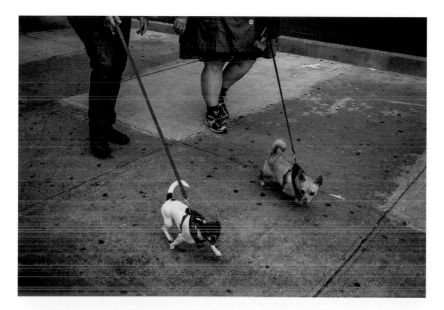

Figure 4-52: People with their dogs.
(24mm, ISO 200, 1/500 sec., f/3.2)

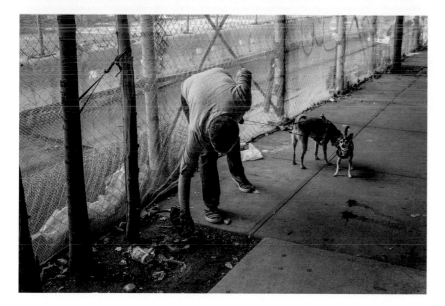

Figure 4-53: New York Poop
There is no ideal place for dog business in the city.
(24mm, ISO 200, 1/200 sec., f/32)

4.4 Portraits

A wide-angle lens is not the ideal tool for traditional portrait photography, where focal lengths from 80–130mm are the norm. Canon's 85mm f/1.8 is a classic portrait lens that enables you to nicely blur the background and very slightly compress your subject's features to produce a flattering image.

Figure 4-54: If you shoot from an appropriate distance, you can capture portraits with *normal* proportions even using a 24mm lens. (24mm, ISO 100, 1/1000 sec., f/3.5)

In spite of this, I want to break with tradition and make a case for using wide-angle lenses for capturing portraits. Wide-angle portraits require careful composition to avoid including too much background detail and to remain true to your subject's proportions. On the upside, wide angles of view give you the potential to capture much more context.

4.4.1 Essentials

Foreground and Background

People often assume that the background in a portrait is simply an annoying distraction that needs to be as blurred and unrecognizable as possible. This often means shooting at maximum aperture, true to the motto, "I've paid for f/1.4, so I'm going to use it!" To break falling into this mold, try deliberately integrating the background in your composition. The depth of field your wide-angle produces forces you to think about the interplay between the foreground and background, and the surroundings automatically become part of the scene, whether you like it or not.

Lines

Look carefully to make sure there are no intrusions such as a tree branch seeming to grow out of your subject's head, or a street lamp apparently attached to a person's shoulder. Remember, too, to check any interplay between the lines in the foreground and those in the background. This is especially important when lines in the background seem to continue as part of the subject—for example, when the horizon coincides with the subject's eye level.

Contrast

Contrast is a useful tool for separating a portrait subject from the background. A bright subject in front of a dark background looks much more impressive than it does in front of a brightly lit background.

Color

Pay attention to the colors in the background. A red traffic light can easily distract a viewer from the real subject. On the other hand, contrasting and complementary colors can be used deliberately to create a relationship between the subject and the background.

Subject Distance

Using a wide-angle lens close up often creates distortion that isn't suited to portraits. Noses tend to look too large and the proportions in a person's face can quickly become strangely distorted if you don't shoot carefully. On the other hand, some comic effects can add a lighthearted note if that is what a particular shot requires.

Figure 4-55: The low viewpoint emphasizes the subject's legs but, thanks to the flamboyant sunglasses, her face retains its importance within the composition. (14mm, ISO 1600, 1/25 sec., f/4)

Figure 4-56: The high viewpoint means that the subject's head and feet are at different distances from the camera. Combined with the wide angle of view, this makes her feet appear tiny. (14mm, ISO 1600, 1/25 sec., f/4)

High and Low

A wide-angle lens highlights and emphasizes the foreground. Nearby objects appear disproportionately large compared with other objects, so full-length portraits often end up showing strange proportions. This effect is particularly obvious when you shoot at such an angle that it makes some parts of the subject farther from the camera than others.

4.4.2 Other Tricks

The Why of Light

Light is the most important ingredient in photography. However, light doesn't just illuminate things—it can be glaring or diffuse, it has color and intensity, and it comes from a specific direction. Aside from the composition, the attributes of light often determine whether a photo turns out exciting and compelling or just plain dull. The ambient light also provides the viewer with a lot of subliminal information about the subject's surroundings.

Figure 4-57: Including the surroundings in this portrait gives us vital information about the time of day and explains the cool light illuminating the subject. (24mm, ISO 6400, 1/125 sec., f/3.5)

In a conventional portrait, the source of light is usually hidden and is not part of the composition. Wide-angle lenses change all that, making it easier to include the light source in the frame. This explains why the lighting looks the way it does and provides the viewer with obvious and subtle clues to the story behind the image.

Figure 4-58: Johannes Vermeer, *The Astronomer*, circa 1668. Many of Vermeer's paintings include a mass of contextual detail and obvious sources of light. Public domain: https://en.wikipedia .org/wiki/The_Astronomer_(Vermeer)

The old Dutch masters were adept at capturing this type of light in their paintings. *The Astronomer* by Johannes Vermeer is a great example. The window on the left is the only source of light in the scene and, because the light source is visible, the painting becomes a study not only of its human subject but also of the light that illuminates it. The globe illustrates the softness of the diffuse light, which becomes dimmer toward the right. The color and direction of light enable us to make deductions about the time of day and even the weather influencing a scene.

Eggheads

Rectilinear wide-angle lenses are designed to keep straight lines looking straight, however, they produce relatively strong distortion toward the edges of the frame. This often has a negative effect on how people and their heads appear (see section 4.4 for more on this subject).

Figure 4-60 is an example of the damage a 14mm lens can do.

Edge distortion is particularly obvious in objects that have proportions we are familiar with—for example, a human head. In our example, the trees at the edge of the frame are heavily distorted but, because we have no immediate reference, they don't appear odd.

Figure 4-59: The model's head is located centrally within the frame and shows virtually no wide-angle distortion.
(14mm, ISO 1600, 1/200 sec., f/4)

Figure 4-60: Positioning the model at the edge of the frame produces obvious wide-angle distortion.
(14mm, ISO 1600, 1/200 sec., f/4)

4.4.3 Examples

Environmental Portraits

Wide-angle lenses really come into their own for portraits that show the subject in her usual environment (e.g., at home or in the workplace). Focal lengths between 24mm and 35mm are firm favorites for this type of shot, as they automatically include plenty of context and they force you to keep a certain distance from the subject. This distance often helps keep exaggerated wide-angle depth effects in check. Figure 4-61 provides an example of this.

Figure 4-61: This image contains lots of context and great depth of field but, because there is nobody else in the frame, the lone person is still the obvious subject. The surroundings give the viewer plenty of detail to investigate and thus become an integral part of the story.
(24mm, ISO 1250, 1/125 sec., f/6.3)

Take your time and carefully compose shots like this, especially if you are including plenty of detail. Too much background activity can distract the viewer's attention from the main subject, but can also play an important role in the story the image is telling.

Figure 4-62: The subject relates to the background, and the image tells a complete visual story. (24mm, ISO 800, 1/125 sec., f/3.5)

With Context

You don't have to include a huge background to tell a story. If you are using a wide-angle lens, a single step backward is often enough to show a subject in relation to her surroundings. Yet here, too, the background plays an important role, providing contrast and a stage. In figure 4-62, despite of the relatively large aperture setting, the minimal background blur ensures that the surroundings play a role in the overall scene.

Negative Space

There are countless ways to organize the individual elements in an image—for example, foreground and background, top and bottom, or geometrical and organic. Organizing a composition involves defining main and subsidiary subjects. In the art world, these divisions are often referred to as positive and negative space, with positive space representing the main subject(s) and negative space representing everything else.

Figure 4-63: A portrait doesn't have to be tightly cropped as long as the subject remains easy to identify.
(24mm, ISO 1600, 1/250 sec., f/4)

WINTER STORIES

Lorem ipsum dolor sit amet, consectetur adipiscing elit. Praesent lobortis massa ac est convallis iaculis. Quisque lacinia porttitor justo, quis blandit purus dictum vitae. Aenean diam nulla, hendrerit eget massa sed, pharetra hendrerit orci. Vivamus gravida vehicula sapien, in condimentum leo accumsan eu. Duis semper purus a eros facilisis, nec posuere lacus ultricies. Maecenas tempus magna magna, sit amet tristique nisl accumsan

Figure 4-64: The large amounts of negative space in this shot make it ideal for editorial use, such as in a magazine.
(24mm, ISO 1600, 1/250 sec., f/4)

In traditional portrait photography, negative space is often considered an intrusion that needs to be cropped or blurred out of existence, often achieved by using a long lens. However, the background in a portrait frequently plays a significant role in the composition and, especially in wide-angle shots, can take up more space than usual.

This is especially true for editorial shots that are used in magazine articles, for example. In situations like these, you need to take a step back

Figure 4-65: In this shot, the strong lines in the negative space create an obvious perspective effect that points toward the subject while also drawing the viewer's attention toward the light. (17mm, ISO 1600, 1/15 sec., f/4)

and give your subject plenty of space. At the same time, take care that you don't include too much distracting detail that competes for the viewer's attention. The subject should always be easily identifiable. In the case of human subjects, make sure your subject is the only person in the frame.

Close-ups

Now that you have learned how to avoid distortion in human subjects by keeping your distance, we are going to do the exact opposite and get right up close. In this case, strange proportions and larger-than-life facial features are a deliberate effect rather than an unhappy accident.

Figure 4-66: Shooting from up close distorts the model's facial expression and makes his nose look much larger than it really is. (14mm, ISO 12,800, 1/80 sec., f/5.6)

Figure 4-67: This clever composition uses the model's clothing and sunglasses to disguise the exaggerated perspective and produce an effective close-up.
(24mm, ISO 1600, 1/160 sec., f/4)

Chapter 5
The Technical View

Now that we have spent some time discussing what makes an image appealing, the following sections take a closer look at the technical side of wide-angle photography. There are few forms of art in which creativity and technology are as closely linked as they are in photography. Wide-angle lenses have a number of idiosyncratic features that can help you improve your overall photographic compositional skills.

We will begin by looking at the effects wide-angles have on sharpness and focus, and then we'll go on to look at how they affect color reproduction and the distribution of brightness within the frame. This chapter concludes with some tips on how to master the unique features of wide-angle lenses and how to use them to give yourself a creative boost.

5.1 Visual Sharpness

The sharpness in a photo depends on the depth of field (i.e., which parts of the image are in focus) and the individual artifacts caused by the optical systems that are part of the lens you are using.

Photographic sharpness is relative and depends on a number of factors that influence what we perceive as being in focus. The resolution of an image, the distance you view it from, and our own eyesight all play a role in how we see an image.

5.1.1 Depth of Field

When we talk about depth of field, we are usually referring to the three-dimensional space in front of the camera. This space is divided into several distinct areas, each running parallel to the camera's focal plane.

Photographic lenses have a built-in minimum focus distance, so objects closest to the camera will be out of focus. This close out-of-focus zone is followed by the plane of focus where everything is sharp, and beyond the plane of focus, everything else is blurred. These three zones have no distinct borders and flow into one another seamlessly.

A pinhole camera is an exception to these rules, as it reproduces everything within its field of view with the same degree of sharpness (or unsharpness). Using a small aperture increases the depth of focus at the expense of the amount of light entering the lens, which in turn increases the required exposure time. Pinhole cameras usually work with exposure times that range from several seconds to many minutes.

The wider the angle of view (i.e., the shorter the focal length), the greater the depth of field a lens will capture. The aperture setting and the subject distance also affect the depth of field.

In general, you can increase depth of field by one or more of the following techniques.

- Using a shorter focal length.

- Increasing the subject distance.

- Setting a smaller aperture.

- Using a different focal length with the same distance and aperture.

Let's take a look at the examples in figures 5-2 and 5-3. The greater depth of field produced by the wide-angle lens is obvious. This makes the background sharper while retaining the same subject distance and aperture setting.

Figure 5-2: Captured using a 105mm focal length at a distance of about six feet, the plane of focus begins near the film spools at front left.
(105mm, ISO 6400, 1/500 sec., f/4)

Figure 5-3: The same picture with a 24mm focal length, shot from the same position. To make the comparison clear, this shot was cropped to show the same area. The depth of field is a bit higher.
(24mm, ISO 800, 1/125 sec., f/4)

Different Focal Length and Distance, Same Aperture

In figure 5.4, I altered the subject distance and the focal length to keep the subject size the same.

This produces only a slight difference in depth of field. Altering the subject distance changes the relative distance between the camera and the subject/background.

Figure 5-4: To keep the subject size the same, I reduced the subject distance in this version to about 16 inches.
(24mm, ISO 800, 1/160 sec., f/4)

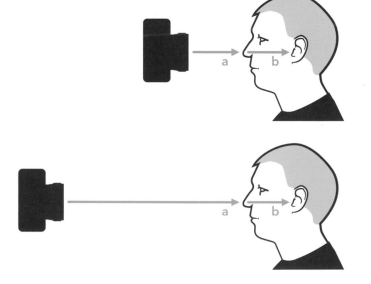

Figure 5-5: When shooting a portrait, we alter the relationship between the distance from the camera to the tip of the subject's nose and the distance from the camera to the background.

Different Focal Length, Sensor Size, and Aperture

Differences are particularly obvious when you compare the results of shooting with a full-frame camera with those from a smartphone. The tiny sensor in the iPhone 6s, with its focal length of 4.5mm, covers the same angle of view as a 30mm focal length in a full-frame camera. Figures 5-6 (taken with a full-frame camera) and 5-7 (taken with an iPhone) were captured at the same distance. I cropped the top and bottom of the iPhone image to give both images the same aspect ratio.

Figure 5-6: Captured at f/4 and 30mm, this full-frame shot has relatively shallow depth of field. (30mm, ISO 1250, 1/160 sec., f/4)

Figure 5-7: In spite of the much wider aperture, the iPhone image has much greater depth of field with the same angle of view. (4.5mm, ISO 32, 1/35 sec., f/2.2)

5.1.2 Sharpness Vignette

In a photographic context, the term vignetting usually refers to a visual softening at the edges of the frame caused by a reduction in brightness or saturation. This effect is particularly prevalent in wide-angle lenses but can be mitigated by selecting a smaller aperture (for more details, see section 5.4).

Blur at the periphery of an image is referred to as vignetting, too. This is caused by the image circle projected by the lens, which sometimes is slightly curved rather than flat. This effect is more pronounced in wide-angles than it is in longer lenses, but here, too, you can reduce the effect

by using a smaller aperture. This increases depth of field throughout the frame and produces sharper details at the edges of the image circle.

Curvature of the field of view is an effect that some photographers use deliberately as a creative tool, and the accessories manufactured by Lensbaby (lensbaby.com) are great for producing this type of effect. Lensbabies use strong lens curvature to leave only the center of the frame in focus and the rest of the image blurred. You can adjust the size of the in-focus sweet spot by altering the size of the aperture.

The Lensbaby 2.0 shown in figure 5-8 is now only available secondhand. Its successor, the Lensbaby Spark, has a fixed aperture of f/5.6.

Figure 5-8: The Lensbaby 2.0 shown here is designed to intentionally produce edge blur and is a favorite among enthusiasts of this type of effect.

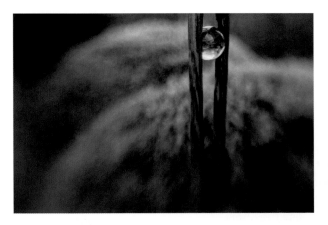

Figure 5-9: Shot using a Lensbaby 2.0 at its widest aperture, this shot has a very small sweet spot.

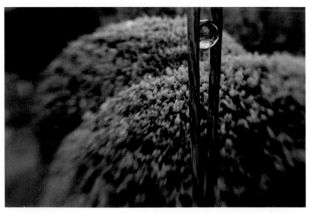

Figure 5-10: Reducing the aperture to f/5.6 visibly increases the size of the sweet spot.

5.2 Sharpness and Motion

Motion blur occurs when the subject or the camera moves during an exposure. If the subject moves, only the subject will be blurred whereas if the camera moves, the entire image will be blurred. This effect can occur unintentionally if the exposure time is too long, but can also be used deliberately as a stylistic device to give an image extra verve.

5.2.1 Camera Shake

You know how it is: the longer the lens, the more difficult it is to keep the camera perfectly still while you shoot. You can only shoot shake-free using a handheld 300mm lens if there is plenty of ambient light available, which enables you to use suitably short exposure times. In low light, you will have to use an image stabilizer and/or a tripod. It is usually easier to shoot shake-free with a 24mm lens.

The increased angular velocity involved when you use a telephoto makes camera shake more likely with longer lenses. When you use a long lens, even tiny camera movements cause significant shifts within the frame, which is why built-in image stabilizers are more common in telephoto lenses than in wide-angles.

Exercise

Use a wide-angle lens to view a nearby subject through your camera's viewfinder. Now use a longer lens to do the same, but move back a little so that the subject appears the same size as it did using the wide-angle. Note how with the long lens, even tiny movements of the camera affect the sharpness of the viewfinder image.

Figure 5-11: Long lenses are more prone to camera shake than wide-angles. You can check this effect by viewing a subject through a wide-angle lens and again through a nonstabilized telephoto. The wide-angle view will be a lot less shaky than the telephoto view.

5.2.2 Rule of Thumb

Analog photographers will be familiar with the tried-and-trusted rule of thumb for calculating shake-free exposure times, which states that: *to avoid camera shake, you need to use an exposure time that is it least the reciprocal of the focal length of the lens you are using.* In other words, if you are using a 100mm lens, you need to use an exposure time of 1/100 second or less to shoot without risking camera shake. For a 24mm lens, the corresponding exposure time is 1/24 second.

Today's photographers have new, more accurate tools at their disposal, and viewing digital images at 100 percent magnification often reveals areas of unsharpness that are impossible to see in a browser view or a 4"×6" print.

To reduce the chance of unwanted camera shake for handheld photos, you need to adjust the old rule.

Instead of:

> *Exposure Time = 1/focal length*

Try halving the exposure time:

> *Exposure time = 1/(2×focal length)*

Therefore, for a 200mm lens, this gives us 1/(2×200) = 1/400s. The corresponding result for a 24mm lens is 1/50s.

The best approach is to try it out. The best settings for your personal shooting style will also depend on how large you display your photos and how steady you are while shooting.

5.2.3 Stability

There are various ways to increase stability while you shoot. Here are some simple tricks that will enable you to use much longer exposure times than the rule of thumb discussed above would have you believe:

1. **Stable footing:** Shooting with both feet flat on the ground provides much more stability than if you are standing on your tiptoes. When you crouch, if you place one knee on the ground, it will increase your stability enormously.

2. **Make contact:** Leaning on a wall or doorframe or placing your elbows on a table will transform you into part of a much more stable structure.

3. **Improve your grip:** Consider how you hold your camera. Let your left hand carry the weight of the camera by pressing your left elbow against your ribs, and then tip the palm of your left hand upward and place the camera firmly in the palm of your hand. You can now operate the camera with your right hand without it having to carry any weight.

4. **Eyebrows:** If your camera has a viewfinder, use it. The contact between your eyebrow and the camera body stabilizes the camera in a similar way to the tips in number 2 above.

5. **The archer mentality:** Perhaps most important, your inner calm influences your stability, too. Observe how still an archer stands at the moment she releases the arrow, and how long she remains still once the arrow has been loosed. A good archer remains perfectly still until the arrow has reached its target, ensuring smooth shooting and improved accuracy. You can use the same approach when you take photos. Imagine you are shooting an arrow when you press the shutter button and remain perfectly still for a second afterward. Become an archer!

5.3 Image Quality: Colors

Your choice of lens (but not necessarily the focal length) influences the colors in your images. The main factor in color reproduction is the type of glass the manufacturer uses. Glass is not optically neutral. It allows different visible wavelengths to pass through with varying strengths, thus influencing the color of the light that reaches the sensor.

When designing a new product, lens manufacturers have to strike a compromise between optical precision, image artifacts, and costs. High-end lenses often have built-in correction elements that automatically alleviate various types of artifacts. Chromatic aberrations—also known as *color fringing*—are one of the more problematic effects, and often depend indirectly on the focal length of the lens.

5.3.1 Chromatic Aberrations

Chromatic aberrations mostly appear in the form of green or magenta fringes along high-contrast edges (i.e., where bright and dark areas meet). Bright sky between tree branches is a classic example of a subject that is almost certain to produce chromatic aberrations.

Figure 5-12: Upstate New York The contrast in this shot is particularly strong where the bright sky shines between the tree branches. (24mm, ISO 100, 1/250 sec., f/10)

Figure 5-13: This enlarged detail shows the strong contrast between the sky and the branches of the tree. Cyan and magenta colored fringes are clearly visible at the edges of the frame.

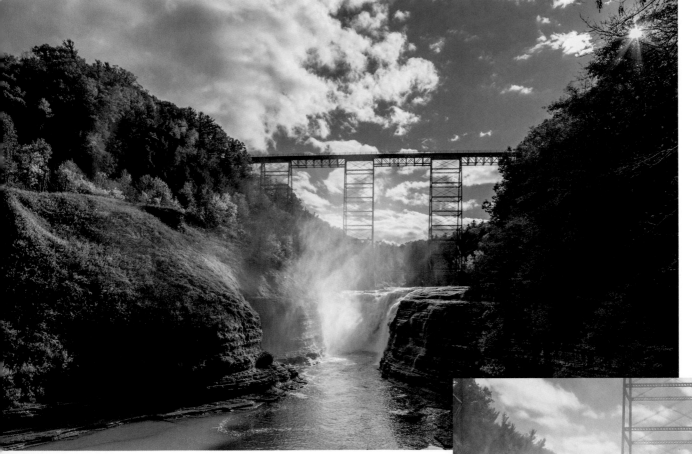

Figure 5-14: Fringing is much less of an issue in the center of the frame.

Chromatic aberrations occur at all focal lengths, but are more prevalent at the extreme ends of the zoom range. Fringing becomes more obvious toward the edges of the frame and occurs because different wavelengths of light are refracted differently by the glass lens elements. The light rays no longer coincide when they hit the sensor and thus areas of unsharpness and color fringing are produced.

Before you rush out to test all your lenses, rest assured that chromatic aberrations don't usually ruin an image. Furthermore, if your lens does produce some fringing, there are various ways to correct it.

The following tips will help you to reduce or correct chromatic aberrations:

1. **Use a corrected lens:** In this type of lens, the manufacturer uses custom corrective elements to shift the focal planes of different wavelengths closer together. Highly corrected lenses are more difficult to manufacture and are usually more expensive.

2. **Use a smaller aperture:** Chromatic aberrations are more of an issue at wide apertures. Stopping down by one or two f-stops help keep these effects in check.

3. **Use image-editing software:** Most image-processing applications have built-in functionality for reducing chromatic aberrations.

Figure 5-15: Software-based correction has almost completely eliminated the fringing effects.

Lens manufacturers use glass of varying refractive indexes to correct optical artifacts. Some of the terms used to describe lenses that contain such elements are AD, ED, Fluorite, SD, and UD. Aspherical elements (abbreviated to ASPH or Asph) are often used to reduce chromatic aberrations. Apochromatic (APO) lenses almost completely eliminate chromatic aberrations.

5.4 Image Quality: Distribution of Brightness

5.4.1 Vignetting from the Image Circle

Figure 5-16: The edges of the image circle are not clearly defined and become gradually darker from the center outward.

Photographic lenses project a circular image into the camera. To keep costs to a minimum, lenses are usually designed so that the image circle just covers the entire rectangular area of the image sensor. The circular image projected by the lens doesn't end abruptly, but becomes gradually darker toward its edges. If you shoot at maximum aperture, light fall-off toward the edges of the image circle is often visible within the image frame. Because the corners of the frame are closest to the circumference of the image circle, it is there that fall-off first appears in the form of a slight vignette. Using a smaller aperture sharpens the fall-off gradient at the edge of the image circle and reduces vignetting.

5.4.2 Vignetting with Filters

Which photographic filters to use and when to use them is a subject of hot debate, but everyone will agree that all filters share the attribute of subtracting parts of the light. Filters reduce flow, whether we are talking about an air filter that traps dust, a water filter that holds back dirt, or a photographic filter that alters the light rays reaching the sensor.

The Earth's Atmosphere

The atmosphere acts as an omnipresent filter that we encounter every day. If the Sun is high in the sky, its light has a shorter route to the Earth's surface and the atmosphere filters out fewer wavelengths. When the Sun is low, its rays have to travel farther, and the atmosphere begins to scatter wavelengths at the blue end of the spectrum. This is why sunsets are predominantly red.

Photographic Filters

Photographic filters do the same thing as the Earth's atmosphere—they only allow certain wavelengths through. For example, a polarizing filter eliminates light rays that oscillate in a specific direction, while a UV filter cuts out all ultraviolet rays. Just as with the atmosphere, the distance a light ray has to travel through a photographic filter influences the strength of the rays that emerge on the other side. Incident light rays have a shorter distance to travel in the center where they hit the filter vertically.

The shallower the angle of incidence, the farther each ray has to travel to pass through the filter and reach the lens. This makes a filter's effect stronger toward the edges of the frame. Fortunately, vignette correction is a standard feature in most image processing software packages.

Figure 5-17: The angle of incidence affects the distance a light ray has to travel through a filter.

The word *filter* is derived from the *felt* mats that were used long ago to filter liquids.

Ultra-wide-angle lenses often have extremely convex front elements that preclude the use of conventional screw-on filters. Instead, such lenses might have a filter holder at the rear of the lens where you can insert filters into the path of light.

Exercise

Look at the outside world through a window with your eye at an angle to the glass. Now open the window and look at the same scene without the window in between. You will see that even common window glass visibly reduces the brightness of the light entering the room.

Polarizing Filters

Polarizing filters deserve a special mention. A polarizer can darken the blue of the sky without altering the brightness of the clouds, thus increasing color depth and contrast.

Figure 5-18: A polarizing filter functions like a kind of comb that only allows light rays through that oscillate in a particular direction.

However, because this effect is heavily dependent on the angle of the light rays it affects, it doesn't always work well with wide-angle lenses. The degree of rotation in the filter alters the strength of the polarization effect, as does the angle between the lens axis and the Sun. The effect is strongest when the Sun is at 90 degrees to the camera—i.e., directly to your left or your right. If the Sun is directly behind or in front of you, there will be virtually no effect.

Taken together, these factors often cause unwanted stripes in skies shot using a wide-angle lens and a polarizing filter. Following are two ways to work around this to capture a homogenous dark blue sky:

- Use image-editing software to reduce the brightness of the blue channel. This tends to work, but only within limits.

- If you are shooting black-and-white with a film camera, use a red or orange filter to darken the blue parts of the visible spectrum. Even modern black-and-white films reproduce blue tones quite brightly and definitely benefit from the use of appropriate filters.

Exercise

View the sky on a sunny day through a polarizing filter and rotate it until the sky is as dark as it gets. Now turn around on your own axis and observe the effect this change of position has on the brightness of the sky.

Figure 5-20: The Luminance sliders in the HSL panel of Adobe Lightroom's Develop module are all in their zero positions.

Figure 5-19: Leaving the color channel settings as captured results in a relatively light-blue sky. (24mm, ISO 200, 1/250 sec., f/10)

Figure 5-22: Reducing the brightness of the blue channel.

Figure 5-21: Reducing the Luminance (i.e., brightness) setting for the blue channel increases contrast and gives the sky a darker, more dramatic look.

The color of the sky results from the effect known as *Rayleigh Scattering* (or Rayleigh Diffusion) [10]. Molecules below a certain size diffuse short-wavelength sunlight to create the blue color we perceive in the sky. This scattered blue light is polarized, which is why the sky looks darker through a polarizing filter. Due to their size, the water molecules that make up clouds are not subject to the Rayleigh effect and thus retain their brightness when viewed through a polarizer.

5.4.3 Vignetting and Angular Response

The performance of a digital image sensor depends on the angle of incidence of the light rays that reach it. Light rays close to the optical axis of a photographic lens hit the sensor vertically, whereas rays from the periphery of the lens hit the sensor at an angle. The wider the angle of view of the lens, the shallower the angle at which light rays hit the edges of the sensor.

Digital Image Sensors

The surface of a camera's sensor is not completely covered with light-sensitive cells. There are spaces between the individual pixels that are required for the printed circuits and other electronic components, often referred to as *metal* by sensor manufacturers. Although pixel density has continually increased with improved manufacturing techniques, it wasn't too long ago that only 30 percent of a sensor's surface was taken up by light-sensitive pixels.

To increase the amount of light the pixels can capture, manufacturers use microlenses to concentrate the light that reaches them. This works particularly well when the light hits the microlens vertically, as it mostly does when you use a telephoto lens. Most of the light captured by a wide-angle lens hits the sensor at an angle, and the angle increases toward the edge of the frame.

Perhaps you have noticed the dark image corners that can sometimes occur when you use an adapter to fit a legacy lens to a digital camera. Nearly all camera manufacturers combat this effect digitally using individual lens correction profiles. These profiles are stored in the camera's memory and are applied via the camera's menu system. When the camera knows which lens you are using, it can automatically compensate for the corresponding vignette effect.

Many image-editing applications use lens profiles to remove unwanted vignetting during the post-processing stage. The distribution of brightness in an image isn't the only application for digital artifact correction, and an increasing number of cameras have built-in geometric correction functionality that reduces barrel distortion in photos captured using wide-angle lenses.

> Viewed from a creative point of view, it is not always desirable to eliminate all the lens errors an image may contain. When it comes to underscoring the message conveyed by an image, distortion and vignetting can be just as important as composition and color.

Improving Angular Response

The electronic components on the surface of an image sensor take up valuable space that could otherwise be used to house light-sensitive pixels. In recent years, increasing numbers of manufactures are switching to backside illumination (BSI) sensor technology, where the wiring is located on the back of the sensor. This increases light sensitivity and provides a wider angular response, thus reducing the vignette effects caused by shallow angles of incidence at the sensor's surface.

Figure 5-23: Light that hits the sensor's microlenses vertically is steered toward the light-sensitive pixel beneath. However, not all the light rays that hit the microlens actually reach the pixel. This effect is especially prevalent at the periphery of wide-angle lenses and produces vignetting at the edges of the frame.

Figure 5-24: The light-sensitive area per pixel is greater in a BSI sensor. This improves low-light performance and produces a wider angular response in wide-angle lenses.

Film Photography

In some respects, film-based photography is superior to digital image capture. The proportion of the surface of the light-capturing medium that is actually sensitive to light is called the fill factor, and the fill factor of film is 100 percent. Because the layers of light-sensitive emulsion in color film are arranged on top of one another, the entire frame is sensitive to all colors. However, the pixels in an image sensor are arranged next to one another with 25 percent of the surface area dedicated to red, 25 percent to blue, and the remaining 50 percent to green.

Figure 5-25: Unlike pixels in a sensor, the light-sensitive particles in photographic film lie in layers atop one another. This makes the entire surface of the film sensitive to light.

Film has near perfect angular response and doesn't require microlenses. Film therefore produces virtually no vignetting when used with wide-angle lenses.

5.4.4 Vignetting from Lens Hoods

Not all the light entering the lens contributes positively to the resulting image. Light sources that lie outside the angle of view of the lens (i.e., light sources that are not actually visible within the frame) often do more harm than good. This results in a variety of lens artifacts and flares, and a reduction in overall contrast.

Uncontrolled light as seen in figure 5-26 is called stray light. It is reflected back and forth between the surfaces of the individual glass elements

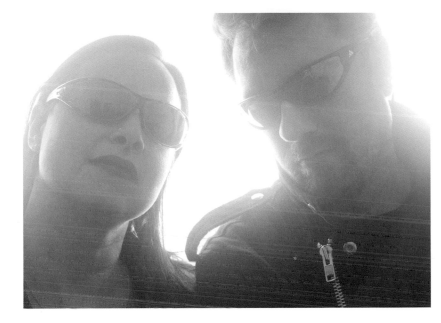

Figure 5-26: The bright light source in the background is pointed directly toward the camera and produces extreme reflections between the individual elements in the lens. The result is stray light that greatly reduces overall contrast.

within the lens. Lens manufactures combat this effect using special antireflex coatings that work in a similar way to the antireflective coatings used in eyeglasses.

The large angle of view in a wide-angle lens increases the probability of stray light creating unwanted effects in an image. This is why many lens hoods have the familiar tulip shape that matches the rectangular sensor rather than the circular lens elements, thus blocking unwanted light sources more efficiently.

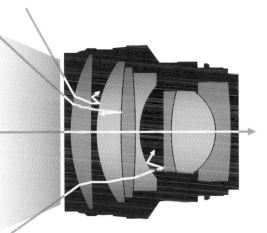

Figure 5-27: Light sources near the edges of the frame often create random stray light artifacts.

Most photographers try to eliminate stray-light artifacts from their images, although they can be used creatively as a stylistic device. Film director J. J. Abrams is a big fan of lens flare, which is a form of stray light effects. These flares often add a feeling he is looking for in the scene. Among other techniques, he often uses spotlights aimed directly at the camera from just outside the frame.

Figure 5-28: Pincushion distortion makes the image appear as if it is bent inward. The effect is particularly obvious at the edges of the frame.

Figure 5-29: Barrel distortion has the opposite effect, producing an image that looks like an inflated balloon. Here, too, the effect is more pronounced at the edges of the frame.

5.5 Image Quality: Distortion

Pincushion distortion and *barrel distortion* are terms used to describe the way certain lenses reproduce straight lines—becoming either curved inward (pincushion) or curved outward (barrel). The strength of these effects varies depending on the type of lens and its focal length.

Exercise

Mount a zoom lens on your camera and point it at a tiled wall so that the lines between the tiles are parallel to the edges of the frame. Capture images of the tiles at both the wide-angle and telephoto ends of the zoom range. Are the edges of the tiles straight in all the images?

When developing new lenses, manufacturers generally use orthoscopic elements that keep straight lines looking straight. Lens distortion isn't an issue in most everyday photographic situations; however, it plays a role in situations where even slightly curved lines are obviously out of place—for example, in architectural shots. It is always better to use a highly corrected lens for this kind of application.

The holy grail of lens design is a bright, lightweight lens that is inexpensive and produces no visible distortion. However, in-lens correction always involves striking a compromise between the following three factors:

1. Maximum image quality (including minimizing distortion)

2. Maximum aperture

3. Minimum purchase price

We are generally limited to any two of the above factors, as it's unlikely to get all three: lenses with high image quality and a bright maximum aperture are expensive; cheap lenses that produce high-quality images require more light; and cheaper lenses with large maximum apertures don't usually score points for overall image quality.

Before you get depressed and throw out all your lenses, here are a few positive thoughts on the subject. Many of the most iconic images in the history of photography were made using lenses that today's photographers wouldn't dare use. Such images have stood the test of time and

are just as moving today as they were when they were created. This is not because of their technical perfection, but rather because they evoke emotion in the viewer. Getting straight lines was the last thing that mattered.

Photographers often encounter comments like, "I bet your camera makes great pictures." However, great chefs are rarely told, "Your pans make great food," and great writers don't hear, "Your pen writes great stories."

Don't worry too much about distortion. Simply go ahead and enjoy the process of creating great images. The distortion that many lenses produce is immaterial in most situations, especially when you are photographing people, animals, or other things we are emotionally attached to. If you find you really can't tolerate the distortion in an image, most image-editing applications have built-in distortion correction functionality that you can apply with just a few mouse clicks.

I very rarely correct distortion as I find that it seldom spoils an image and more often than not adds some extra pep.

Figure 5-30: Feelin' Good Bluesband
The obvious barrel distortion increases toward the edges of the frame, and the effect is accentuated by the repeated lines in the background. The faces are all close to the center and are largely unaffected.
(14mm, ISO 800, 1/125 sec., f/4)

5.5.1 Computational Photography

This term describes an increasingly popular digital photo trend. Most image-editing applications are able to correct pincushion or barrel distortion, and many can even exaggerate it.

Figure 5-31: It is possible to create pincushion distortion digitally—a function that you can also use to correct barrel distortion.

Figure 5-32: Artificial barrel distortion can be used to correct pincushion distortion.

A few years ago, a serious computer was required to correct image distortion, whereas today, it is often performed automatically by the camera's firmware. Invisibly to the user, the camera resamples the data it captures to produce perfectly straight lines wherever distortion occurs.

An Example

Micro Four Thirds cameras have featured digital correction techniques for a number of years, and these are becoming increasingly common in other types of camera, too. The first version of Sony's RX100 compact camera was one of the first cameras that showed obvious progress in this area. Technological progress means that the image the lens delivers to the sensor is only vaguely similar to the one that ends up saved on your memory card.

Instead of using expensive, corrected lenses, camera manufacturers often leave it to the software to correct lens errors, making it possible to use smaller, less expensive lenses. Lenses with built-in error correction elements are much larger and heavier.

If you shoot JPGs, the camera corrects color, contrast, and sharpness for you anyway. Increasingly powerful processors make adding geometric corrections to the mix a relatively simple step.

If you shoot RAW, geometric corrections are not usually implemented automatically to your image files. However, some camera manufacturers have cooperated with leading image-processing software manufacturers to develop distortion correction that is applied invisibly and automatically when RAW images are opened for editing.

So what does all this mean for the future of photography? Until recently, correcting distortion, vignetting, and chromatic aberrations was the lens manufacturer's job. Nowadays, these tasks are increasingly performed by in-camera software, which is sure to have an effect on the size and cost of lenses and cameras alike.

5.5.2 Software

Simple distortion is easy to correct using most image-processing applications. However, some lenses produce complex distortion comprised of multiple lens errors that is more difficult to correct digitally. A common type of complex distortion is called *mustache distortion*, where the distortion is heavier at the center of the frame than it is at the edges.

Even with a lens that produces obvious complex distortion, the situation dictates whether its effects are relevant to the results. There is no reason not to use distorting lenses to capture landscape or starscape images. If you use profile-based post-processing software such as PTLens [11], you can even use lenses like these for architectural shots.

A quick Web search will reveal profiles for most lenses and most image-processing applications, including Lightroom.

Figure 5-33: The term mustache (or complex) distortion describes a combination of pincushion and barrel distortion that makes horizontal lines curve in the shape of a handlebar mustache.

Figure 5-34: Aurora Borealis Captured using a Rokinon 14mm f/2.8 lens. This lens is well known for its strange mustache distortion. However, in this shot, no lines run parallel to the edges of the frame, so the effect is not noticeable and corrections are unnecessary.

5.6 Image Quality: Skewed Lines

Most wide-angle lenses reproduce straight lines correctly, but some produce straight lines that lean. This is a symptom of the basic optical characteristics of the lens and doesn't affect overall image quality. However, because it is similar in character to the distortion discussed above, I have included a short section about it in this chapter.

The shorter the focal length, the wider the angle of view and the stronger any distortion effect will be toward the edges of the frame. This is due to the way the lens projects the image into the camera. The shallower the angle between a line and the optical axis of the lens, the longer and more skewed the line will appear toward the edges of the frame.

Figure 5-35: Depending on its position, the line **x** is projected at different lengths by the lens. The closer the projected line lies to the edge of the frame, the longer and more skewed it will appear.

x

x

y

2×y

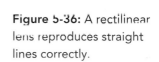

Figure 5-36: A rectilinear lens reproduces straight lines correctly.

Figure 5-37: This 65mm wide-angle shot from a 4×5 large-format camera shows skewed lines all the way up to the edge of the frame, visible in the traffic light and the street lamps on both sides. The bicycles in the center are distortion-free.

Fisheye Lenses

Fisheye lenses take a completely different approach and intentionally produce significant distortion. They capture huge angles of view, but with virtually no straight lines.

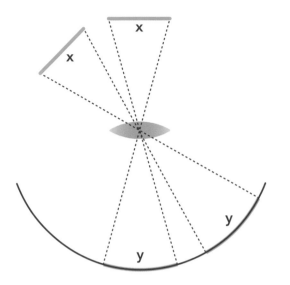

Figure 5-38: A fisheye lens doesn't increase the size of objects toward the edge of the frame, but distorts all straight lines.

Figure 5-39: Nearly every straight line captured using a fisheye lens looks curved.

Figure 5-40: The curvature of lines captured with a fisheye lens increases toward the edges of the frame. This distortion is the price you pay for capturing an extremely large angle of view in a single shot. (2.73mm, ISO 145, 1/30 sec., f/2.8)

There is no right or wrong way to approach distortion. Either you have straight lines that are skewed toward the edges of the frame or you have straight lines that look curved. In the latter case, the proportions remain correct, but the overall feel of the image is spherical.

The choice between straight and curved lines is a matter of taste and depends on how you want the resulting image to appear. Most photographers prefer the straight-line approach, as this creates an effect that is closer to real-world human perception.

5.7 Image Quality: Field Curvature

The field of focus projected by a lens isn't always flat. Curvature in the field of focus produces unsharp areas at the edges and corners of the frame. To counteract this effect, camera manufacturers are working on producing curved sensors, and several have already been patented. A curved sensor corrects errors due to field curvature without having to correct the lens, making it possible to use cheaper, lighter lens designs.

Making the aperture smaller (i.e., stopping down) increases the depth of field projected in the camera and makes a curved plane of focus *thicker*, thus offsetting edge blur effects. Some analog cameras were built with a curved film plane for precisely this reason. The Bilora Boy made of Bakelite and sold in Germany in the 1950s—was designed for use with 127-format roll film, which was loaded tight to the curved film carrier. This rectified some distortion and helped reduce edge blur.

Figure 5-41: The Bilora Boy has a curved film carrier.

5.8 Panoramas: Wide-Angle Photos without Wide-Angle Lenses

Even if you don't own a wide-angle lens, you can still capture images with a wider angle of view than your lens is designed to capture. This is achieved by using specialized software to stitch a series of overlapping photos together to make a single panoramic image.

Figure 5-42: A panorama is made up of multiple overlapping images.

The most common way to shoot a panorama is horizontally, and most current cameras and smartphones have horizontal panorama functionality built in. All you have to do is pan the camera while you shoot and the software does the rest. The results are usually quite good.

You can gain a little more control over the process if you shoot individual source photos and stitch them together using dedicated panorama software. The usual approach is to shoot from left to right, leaving plenty of overlap between shots.

Panorama Photography Tips

- **Portrait format:** To give your panorama more vertical scope, try shooting your source images in portrait format (i.e., with the camera held vertically, in portrait orientation). The best way to shoot shake-free in portrait format is to rest the camera on the palm of your left hand and position the shutter button at the top. This way, your shutter hand doesn't carry any weight and is less likely to shake.

- **Focus:** It's easier to stitch your source images together if they all have the same point of focus. Switch to manual focus and select the point you want to focus on before you begin shooting.

- **Manual exposure:** Switch to manual exposure mode and use the same exposure settings for each source image. If you use auto mode, each exposure will be slightly different, making it harder for the stitching software to produce an even-looking result.

- **Manual white balance:** The same applies to white balance. Varying colors in the source images make stitching much trickier.

- **Overlap:** Make sure your source images have enough overlap: 30–50 percent overlap is a good ballpark figure.

- **Movement:** Stitching works best when there are no obvious changes between the source images. For example, a successful panorama that contains trees in the wind is a tough job for any stitching software.

Figure 5-43: This 77-megapixel portrait-format panorama was made from nine source images.

Figure 5-44: A magnified detail view shows just how much resolution the composite image has.
(70mm, ISO 400, 1/3200 sec., f/5.6)

If you find it difficult to locate your panoramic source images among the haul you bring back from a trip, try shooting a marker image at the start and finish of the panoramic sequence. This can be a raised thumb, your feet, or whatever—the important thing is that you recognize it quickly when sorting through your images later on.

Figure 5-45: Panoramas can be made from multiple rows of source images. This is a sketch of nine overlapping images (three rows of three images each).

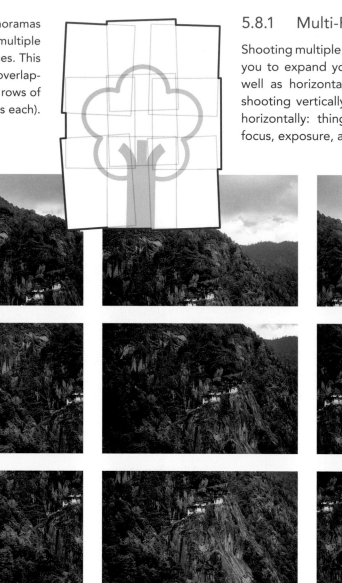

5.8.1 Multi-Row Panoramas

Shooting multiple rows of source images enables you to expand your angle of view vertically as well as horizontally. The same rules apply to shooting vertically as they do when you shoot horizontally: things work out best if you set focus, exposure, and white balance manually.

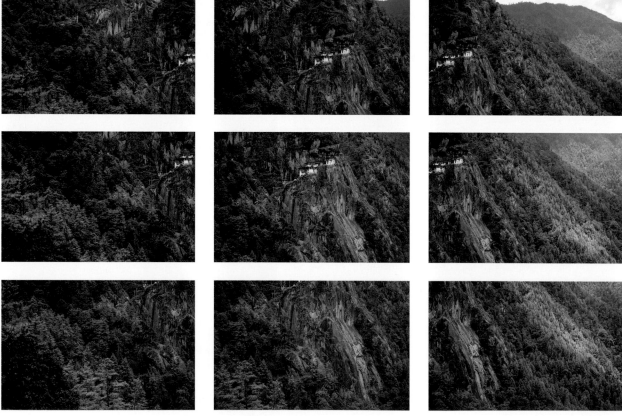

Figure 5-46: Tiger's Nest, Bhutan
These 12 source images were all captured using a 70mm focal length setting.

These techniques enable you to capture *very high-resolution* images that contain a greater angle of view than your lens normally allows. A finished 3×3 panorama made from nine 20-megapixel source images can be as large as 50–100 megapixels, even accounting for image overlap during stitching.

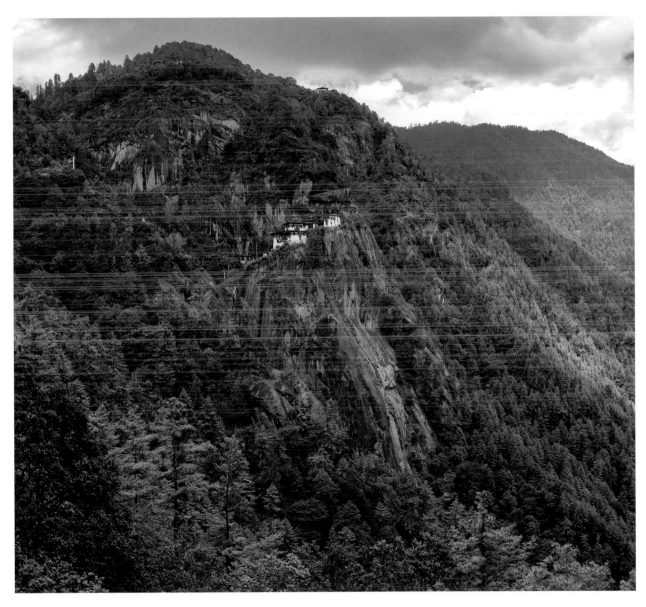

Figure 5-47: Figure 5-46 ended up as a 109-megapixel ultra-wide-angle image.

5.8.2 Fill Functions

Stitching a panorama always produces an image with ragged edges that you will need to crop to size. Cropping eliminates some of your hard-won additional angle of view, but you can often rescue parts of a panorama using image-processing software.

Fill for Panoramas

Most high-end image-editing applications have some kind of smart fill function that enables you to create new pixels to fill gaps produced during stitching. Simple features such as sky or grass are relatively simple to mend, and some programs can cope with more complex patterns, too. The best way to find what works is to try it out. The results are often quite respectable.

Figure 5-48: Stitching a multi-row panorama usually produces an image with ragged edges.

In Affinity Photo, the fill-in tool is called *Inpainting Fill*, while the equivalent Photoshop tool is called *Content-Aware Fill*. The GIMP *Resynthesizer* plug-in does a similar job, and often produces surprisingly good results.

Lightroom's built-in panorama function now includes the *Boundary Warp* option, which enables you to automatically *bend* the edges of a stitched panorama to fill any gaps left by the overlaps. This works well in most landscape panoramas, but you are probably better off using other methods for completing the straight lines required in most architectural shots.

Figure 5-49: Lightroom's Boundary Warp slider *bends* a stitched image to fill gaps left at the edges of the frame after stitching. The downside of the tool is the fairly obvious distortion it produces. This specific image already has a lot of intentional distortion, so Boundary Warp is perfectly usable here.

5.8.3 The Reduced-Depth-of-Field Trick

Panoramas have other tricks up their sleeves, too. If you shoot a multi-row panorama of a relatively close subject using a long lens, the resulting image will have a wider angle of view than the focal length you used would allow while retaining the depth of field of that longer lens. This technique was popularized by New York wedding photographer Ryan Brenizer, and is often referred to as the *Brenizer Method*.

Figure 5-50: This image was created from 16 source images captured at f/5.6 and 300mm, resulting in an equivalent overall focal length of 90mm. Nevertheless, the image has the depth of field of an image shot using a 300mm lens.

Figure 5-51: This image was captured at f/5.6 using a 90mm lens. The angle of view is the same as in the previous image, while the depth of field is that of a 90mm lens.
(90mm, ISO 100, 1/160 sec., f/4)

Large-format cameras are another way to capture wide angles of view and shallow depth of field. The normal focal length for a 4×5 camera is 150mm, so the photos it captures have an angle of view equivalent to that of a 50mm lens on a full-frame camera, but with the depth of field of a 150mm lens.

5.9 Lens Buyer's Guide

As a photographer, podcaster, and workshop leader I am often asked which lenses I recommend. There is a huge range of lenses with similar specs available, so it is tricky to know where to start looking. The sheer variety of lenses offered makes it difficult for me to offer concrete advice, but the following information should provide some guidelines to help you make your own purchasing decision.

Superzooms

There are plenty of zooms in the $500 to $700 range that offer a large zoom capability, often stretching from as little as 16mm all the way up to 300mm. These lenses are great for photographers who prefer to use a single lens rather than a bunch of lenses with fixed focal lengths or smaller zoom ranges.

On the other hand, superzooms always involve design compromises. Image quality often suffers at the extreme ends of the zoom and aperture ranges, while midrange settings have the potential to produce respectable results. The problem here is that everyday photography often takes place at the extreme ends of the zoom range. Furthermore, the maximum aperture offered by this type of lens is not especially large, which leads to longer exposure times and increased risk of camera shake. Put simply, optical performance suffers at extreme settings.

Nevertheless, these lenses are useful in many situations and, when used with midrange settings, often produce images that are just as good as those from more expensive lenses. Sharpness and contrast are only two of a number of criteria for judging image quality anyway, and a poorly composed image with sharp details and great contrast remains a poorly composed image any way you look at it. Many of the iconic photos of the last 100 years were captured using lenses that today's photographers would never consider using.

Wide-Angle Zooms

Wide-angle zooms cover a range of focal lengths that are all classified as wide-angle. They are designed specifically for different sensor types (Micro Four Thirds, APS-C, or full-frame) and have zoom ranges such as 7–14mm, 11–22mm, or 20–40mm. Prices start at around $300 but can reach $2,000 or more for a high-end lens with a maximum aperture of f/2.8. Most wide-angle zooms have a maximum aperture of f/4 and cost between $300 and $1,000.

Wide-angle zooms are not generally prone to camera shake and rarely have built-in image stabilizers. They are also simpler to manufacture and have fewer elements than longer zooms, often resulting in better image quality.

Prime Lenses

Fixed focal length (or *prime*) lenses don't require the complex mechanics of a zoom and are therefore easier to design and build with larger maximum apertures than their zoom counterparts. However, simple designs don't always equate to low prices. Prime lenses often have much better edge performance and produce fewer lens errors. As with all lenses, the larger the maximum aperture the higher the price.

Opposite:
Figure 5-52: Khumbu Cow
(17mm, ISO 200, 1/400 sec., f/8)

Chapter 6
Tilt-Shift Part 1:
The Basics

6.2 Tilt-Shift Functionality

Let's take a closer look at tilt-shift functionality. Chapter 8 includes some hands-on examples of how to use it.

6.2.1 Shift

The shorter the focal length, the more pronounced the converging lines in the resulting image will be. This is why shifting to correct perspective is the most widely used function in wide-angle tilt-shift lenses.

In figure 6-4, I used a spirit level to set the camera up parallel to the front of a building. This ensured that the vertical lines in the subject remained parallel but meant that the vertical height of the building no longer fit within the frame.

Figure 6-4: For this shot, I used a spirit level to set up the camera. This ensured that the vertical lines remained parallel, but meant that the building no longer fits within the frame. (24mm, ISO 100, 1/80 sec., f/11)

A spirit level is an essential tool for architectural photography. If you don't have one on hand, you can use the grid in your camera's viewfinder or the grid etched on the focusing screen to lines things up.

To capture the entire building in a single frame, you have to tip the camera backward, but this causes the vertical lines to converge and makes the building look as if it tipping backward. Instead of tilting the camera,

Figure 6-5: Tilting the camera enables you to fit the entire building into the frame but makes it look as if it is tipping backward.

the solution lies in keeping the camera parallel to the subject and shifting the lens vertically. The building will now fit within the frame and the vertical lines will remain parallel.

Figure 6-6: Shifting the lens enables you to fit the subject into the frame while keeping its vertical lines parallel.

Alternatively, you can capture your image with converging lines and correct them later during post-processing. In Adobe Lightroom, this is achieved using the Upright function. Perspective correction always leaves blank areas in the transformed image so you will have to crop it after you have performed the transformation.

Figure 6-7: When correcting converging verticals digitally, blank areas at the edges of the image will need to be cropped out.

The digitally corrected image has a smaller angle of view than the version shot using the shifted lens, even though the same focal length was use to capture both.

Figure 6-8: The digitally corrected version is missing some of the detail that surrounded the subject in the original image.

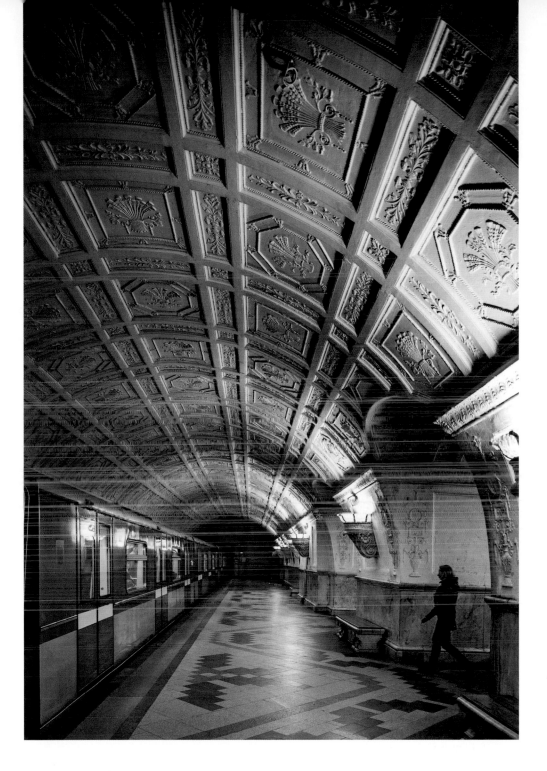

Selective Emphasis

Correcting converging verticals is only one aspect of wide-angle shift functionality. Lens shift can also be used to deliberately emphasize selected elements within the frame.

Figure 6-9: The Moscow Metro Lens shift gives the intricate ceiling more emphasis without having to tilt the camera.
(24mm, ISO 1600, 1/80 sec., f/3.5)

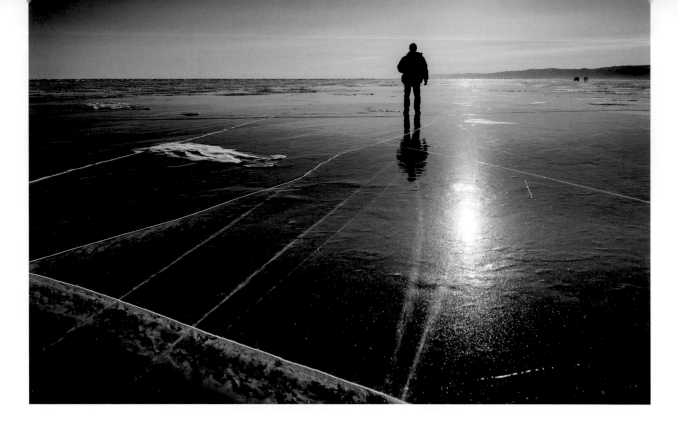

Figure 6-10: Lake Baikal, Siberia
Lens shift emphasizes the fore-
ground in this composition.
(24mm, ISO 200, 1/6400 sec., f/7.1)

6.2.2 Tilt

In a conventional lens, the plane of focus lies parallel to the film/sensor plane, and anything that is reproduced in front of or behind the plane of focus will no longer appear sharp. A tilt-shift lens adjusted to its zero position behaves in exactly the same way. However, tilting the lens alters the position of the plane of focus—an effect that was first described more than a hundred years ago by the Austrian cartographer Theodor Scheimpflug [12].

This plane-of-focus effect can be used as follows:

* Tilt the plane of focus so it is no longer parallel to the image plane. In a landscape, you can adjust the plane of focus to coincide with the ground or, in an architectural shot, with the front of a building.

* Tilt the plane of focus backward to focus on a selected detail and leave the rest of the image out of focus.

Figure 6-11: Mini pilot, Washington, DC
This image uses tilt functionality to
place the plane of focus precisely on the
child's goggles while throwing the rest
of the image out of focus.
(24mm, ISO 1600, 1/30 sec., f/4)

6.3 Tilt-Shift in Practice

6.3.1 Tilting and Shifting

A tilt-shift lens has a variety of knobs and levers for adjusting the settings.

Figure 6-12: Shift functionality is controlled using a knurled knob. The locking screw is on the opposite side of the lens body.

Shift

To shift the lens, you first have to loosen the locking screw. An embossed scale on the lens body helps you set the correct degree of shift.

Tilt

Tilt, too, is controlled using a rotating knob. The embossed scale shows the degree of tilt.

Figure 6-13: The knob for adjusting the angle of tilt.

6.3.2 Rotation

Most tilt-shift lenses also have an additional function that enables you to rotate the lens in 45-degree steps around its own axis. This enables you to use the tilt-shift functionality with the camera in either portrait or landscape orientation. Most tilt-shift lenses allow you to use the tilt and shift functions independently of one another.

Figure 6-14: This lever unlocks the lens rotation function.

6.3.3 The Image Circle

Photographic lenses project a circular image into the camera body. To keep manufacturing costs to a minimum, lenses are constructed so that the image circle is just large enough to completely cover the image sensor.

Shifting the lens parallel to the image plane shifts the image circle projected by the lens. If the image circle is too small, this results in vignetting around the edges of the projected image. To counteract this effect, tilt-shift lenses project a larger image circle than would otherwise be necessary to cover the image sensor.

Figure 6-15: The image circle projected by a tilt-shift lens is larger than the sensor. This keeps the image bright when you use large tilt or shift movements.

Although there are currently no dedicated Micro Four Thirds tilt-shift lenses available, you can use shift adapters for mounting full-frame lenses on cameras with smaller sensors. Shift adapters are also available for mounting medium-format lenses on full-frame cameras. In other words, a full-frame tilt-shift lens is actually a medium-format wide-angle.

6.3.4 Shooting By Hand

Manual Focus

Autofocus doesn't work with tilt-shift lenses. This is probably because the mechanics of the lens leaves insufficient space for additional electronics, and because autofocus sensors in the camera body have to be parallel to the image plane to work properly. This means that tilt-shift autofocus sensors would have to tilt with the lens, and that would involve a technical effort that is too complex for this kind of niche application.

Manual Exposure Metering

Shifting the lens means that light captured by the lens no longer hits the metering sensor head-on, thus causing metering errors. Attempts to meter automatically while using a shifted lens often end up overexposed by several f-stops. Automatic metering only works with the lens set to its zero position.

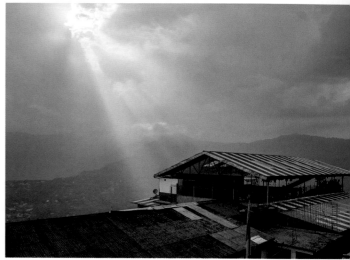

Figure 6-16: Lens shift usually causes overexposure if used with automatic exposure metering.

Figure 6-17: Manual exposure metering is the solution.
(24mm, ISO 400, 1/2000 sec., f/8)

6.4 Larger Sweet Spot

A lens with an oversized image circle also offers improved image quality. Lens developers have to make sure their products illuminate the sensor evenly (i.e., reducing vignetting) while keeping chromatic aberrations to a minimum. They also have to keep the image plane as flat as possible to ensure constant image sharpness throughout the frame. Technical lens tests measure all these parameters—from vignetting to edge blur—and the results show that all photographic lenses produce their best performance in the center of the frame. Image quality always falls off toward the edges of the frame.

This is where the larger image circle projected by a tilt-shift lens comes into its own. If you set your lens to its zero position, the entire sensor will be illuminated by the center of the image circle where vignetting, chromatic aberrations, and field curvature are at a minimum, and detail sharpness is at its best.

Used in its zero position, a tilt-shift lens will typically produce high-end image quality.

6.5 Tilt-Shift Zoom

Tilt-shift lenses are available only with fixed focal lengths. Although various patents for zoom versions have been registered, the effort involved in developing a usable tilt-shift zoom is simply not cost effective. Furthermore, the focal lengths that are available are aimed at specialists who use these lenses for specific purposes. Architectural and landscape photographers often use 24mm versions, while product and advertising photographers are more likely to use 50mm or 90mm models.

6.6 Comparability

Is a tilt-shift lens comparable to a conventional prime lens with the same focal length? If the tilt-shift lens is used in its zero position, the angle of view will be the same, but the comparison breaks down the moment you use shift. A tilt-shift lens offers a huge degree of creative flexibility when it comes to image composition.

My example in section 6.2 shows that tilting a lens and correcting the results during postprocessing delivers a narrower effective angle of view than a dedicated tilt-shift lens would capture.

Furthermore, you can judge your results in real-time when you use a tilt-shift lens, which takes the guesswork out of complex compositions.

6.7 Tilt-Shift for Everyone

A quick look at a lens manufacturer's price list explains why tilt-shift lenses remain a niche phenomenon. The high–end requirements of this type of lens result in prices that start at around $700 for third-party models and can exceed thousands of dollars for models from brands such as Canon and Nikon. The image circles projected by tilt-shift lenses are as large as those projected by medium-format lenses, and the glass elements of appropriate size and quality are complex and expensive to produce. Tilt and shift movements also increase the risk of internal reflections within the lens, so the glass has to be treated with high-end coatings, too. Finally, because they are highly specialized, tilt-shift lenses are produced in small quantities, driving the prices up even higher.

The following sections describe some alternative, cheaper ways to get started in the fascinating world of tilt-shift photography.

6.7.1 Secondhand Gear

A new tilt-shift lens is so expensive that a purchase is hard to justify for most amateur photographers. My first tilt-shift was an early 24mm Canon TS-E that I bought secondhand from an architectural photographer who had used it constantly for many years. It had plenty of dings and wear on the body, but the mechanics were fine and the lens elements were clear and fungus-free, so the asking price of around $500 seemed like a bargain to me.

You can often find pre-owned tilt-shift lenses online for $700 or less, and reputable dealers often have one or two lying around. I have had some good deals from KEH Camera [13], where there is always a good selection of lenses at reasonable prices. Furthermore, KEH has its own workshop where it refurbishes and tests all its lenses. B & H Photo [14], also sells used equipment and offers many used lenses to choose from.

Figure 6-18: My heavily used Canon TS-E 24mm, f/3.5.

6.7.2 Rentals

Renting a lens is a great way to find out whether tilt-shift floats your boat without spending too much money up-front. Try renting one for a weekend and check out whether the options it offers impress you enough to consider a purchase.

6.7.3 Lensbaby

Considered a toy by many, the original 2004 Lensbaby was a weird plastic lens with built-in bellows that enabled the user to manually alter the distance and angle of the lens in relation to the sensor. This might sound complicated, but it's actually quite intuitive once you get to play with one. The company now sells a fairly wide range of lenses, but the models I have the most fun with are the original Lensbaby (up to version 2.0), the Muse, and the Spark.

A Lensbaby is a kind of tilt-shift lens produced for the masses, with built-in tilt and shift movements, albeit not very precise ones. The optical quality of a such a lens is not perfect, and its strong field curvature means it only focuses in a relatively small sweet spot that you can move around the frame by manipulating the built-in bellows. While the original Lensbaby came with a range of swappable apertures that enabled you to alter the size of the focus sweet spot, the current Spark model has a fixed aperture of f/5.6. It is still a lot of fun to use and produces intentionally out-of-focus images with a unique, dreamlike feel.

Figure 6-19: The Spark is the current Lensbaby bellows lens.

6.7.4 Freelensing

The technique called *freelensing* can work with any combination of lens and camera. Instead of actually mounting the lens on the camera's bayonet, it involves holding the lens in your hand in front of the camera. All you need is a little courage and a steady hand. The advantage of this approach is that you can then tilt and shift any of your lenses. To prevent stray light from spoiling their images, experienced freelensers often mount a black sock with the toe cut off between the camera and the lens to serve as a kind of flexible lens barrel.

An alternative method is to use medium-format lenses attached to a full-frame camera body using bellows made of car parts or plumbing supplies.

All this has little to do with precision photography, but the images you can create this way have intrinsic artistic value and offer interesting focus effects. The construction of improvised tilt-shift lenses is actually quite closely related to the way a conventional view camera is built, with its movable standards and flexible built-in bellows.

If you go freelensing without using some kind of tube between the camera and the lens, there is a serious risk of getting dust and dirt in your camera. But never fear, the Lensbender Lenshield [15] is a custom accessory with a built-in window available for Canon, Nikon, and Sony mounts that seals your camera while you freelens. Freelensing also increases the effective flange focal distance of your camera, which—like an extension tube—reduces the focus distance.

A final hurdle when using this technique is the aperture, which can only be adjusted electronically in most digital cameras. In its zero position, the aperture is usually either wide-open or closed all the way down. Both of these states aren't much use to freelensers once the lens is removed from the camera, so this is where legacy prime lenses come in. Normal analog lenses cost very little on the secondhand market and they enable you to select any aperture you want. Furthermore, for freelensing purposes, it isn't necessary to use a lens with a mount that is compatible with your camera.

Figure 6-20: The Lensbender Lenshield uses a pane of optical glass to protect the internals of your camera from dust and dirt while you are freelensing.

6.7.5 Tilt-Shift Adapters

If freelensing is a bit too freeform for your taste, there is a wide range of tilt and shift adapters available for regular lenses, too. The most important thing to remember, if you take this approach, is that the lens you use must have a larger image circle than your camera normally requires. Full-frame lenses work well with mirrorless Micro Four Thirds and APS-C cameras, while medium-format lenses are the best choice for full-frame cameras. When working with adapters that don't have additional optical elements, you will need a lens with a greater flange focal distance than the target system.

Tilt, shift, and combined tilt-shift adapters are available at surprisingly low prices from brands such as Kipon [16]. If you're a bit more adventurous, you could also try to track down adapters by MIREX and Zoerk, which are sold internationally.

> Flange focal distance is the distance between the camera's bayonet mount and the sensor. This distance varies from camera to camera and, among other things, determines the minimum focus distance. If the flange focal distance is too great, many lenses can no longer focus to infinity. Generally speaking, if you want to use a third-party lens with an adapter, the source system (i.e., the lens) needs to have a greater flange focal distance than the target system (i.e., the camera). For example, a medium format lens from the Mamiya 645 system (flange focal distance 64mm) should work well with an adapter for the Canon EF mount, with its flange focal distance of 44mm. Adapting full-frame lenses for use with Micro Four Thirds cameras is even simpler, as the difference in flange focal distances between the two systems is much greater.
>
> See table D-1 in the appendices for more details on the flange focal distances of most common photo systems.

6.7.6 Software Simulation

Tilt-shift lenses have recently become very popular due to the rise of the *fake miniature* effect, although you can imitate this effect quite successfully using software alone (see section 7.6.5 for more on this topic).

📷 Previous Spread:
Figure 7-1: Moscow Market
(24mm, ISO 800, 1/160 sec., f/3.5)

Tilt-shift lenses are available with focal lengths ranging from 17mm to 135mm, although you can extend these quite radically using adapters. This chapter concentrates on traditional wide-angle tilt-shift applications, such as architecture and landscapes. However, tilt-shift lenses are well suited for use in other genres, too, and there are a number of interesting tricks for pepping up portraits and product photos using these lenses.

7.1 Architecture

For the purposes of this chapter, I am going to use a fairly broad definition of the term *architecture*. In a photographic context, the basic rules of shooting buildings are also valid when you are working with things such as transportation systems and other manmade contrivances. Architectural photography without tilt-shift lenses is virtually unthinkable, and there is no better tool for keeping vertical lines parallel while shifting the horizon. Tilt-shift lenses are also perfect for accentuating selected image elements—for example, by deliberately emphasizing edge distortion. You can even use a tilt-shift lens with its aperture wide open to precisely place the plane of focus along the planes of three-dimensional shapes. Aside from all these tricks, the best part of working with tilt-shift lenses is that you can see the results of your adjustments in real time: what you see is what you get!

7.1.1 Perspective Correction

Before we go any further, I need to explode a myth: shift lenses do not correct perspective. What they actually do is prevent altered perspectives from being reproduced in uncorrected form. We are talking here about the converging lines that occur when you tilt the camera to squeeze a building into a single frame. The converging verticals that result make buildings appear to tip backward.

In serious architectural photography, converging verticals are usually only acceptable when the effect is so severe that it is obviously meant to be deliberate.

This is how to use a tilt-shift lens to prevent converging verticals:

1. Use a spirit level to set up your camera vertically and horizontally. There should be no tilt forward, backward, or to the left or right.

2. Compose your image and, instead of tilting the camera, shift the lens up or down parallel to the image plane.

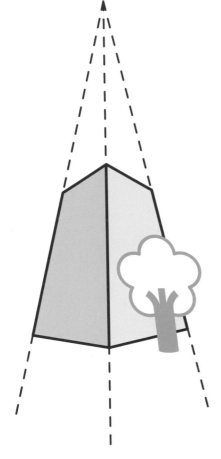

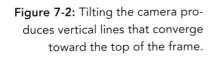

Figure 7-2: Tilting the camera produces vertical lines that converge toward the top of the frame.

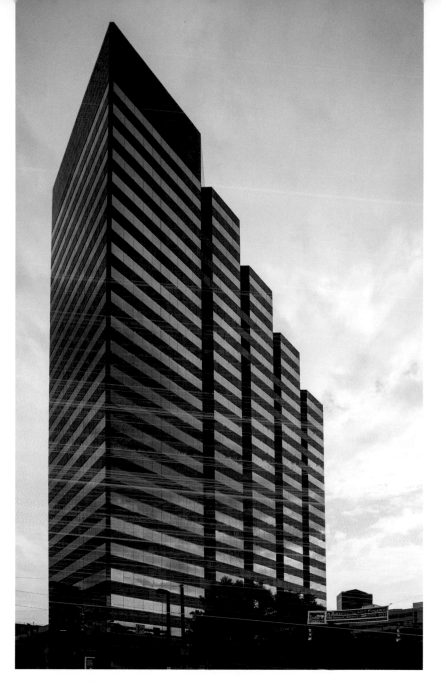

Figure 7-3: An example of an extreme shift effect.
(17mm, ISO 200, 1/1600 sec., f/5.6)

And that's it! A quick look through the viewfinder will confirm that any parallel lines in the subject remain parallel in the resulting shot.

Depending on the lens you use, you will find that you have a surprisingly large amount of leeway for this type of adjustment.

7.1.2 Emphasizing Key Elements

A further application for lens shift that is only slightly related to parallel lines is accentuating key elements in an image that you would normally have to tilt the camera to capture. Shifting the lens enables you to add more sky to an image or shift the horizon to emphasize the foreground without altering the perspective.

Without shift functionality, I would have needed to tilt the camera for figure 7-4, which would certainly have produced unwanted converging verticals.

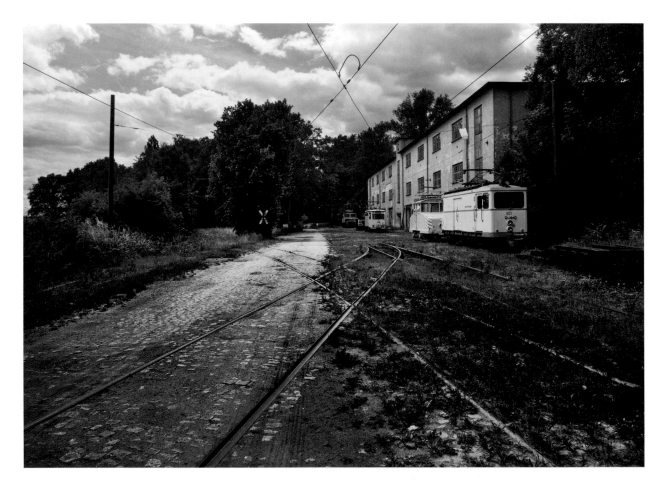

Figure 7-4: Hannover Tramway Museum, Sehnde, Germany Analog 4×5 large-format camera.
(65mm, ISO 400, 1/15 sec., f/22)

As we have already seen, because a tilt-shift lens is actually a wide-angle lens with an extended image circle, tilting the camera has a different effect to shifting the lens.

In section 3.1 we looked at the distortion that often occurs at the edges of wide-angle shots. Although it tends to spoil images of people, this effect can be really useful for highlighting selected elements of nonhuman subjects.

7.1.3 The Vignette Trick

Wide-angle lenses tend to darken the corners of the image, especially when used with the aperture wide open. Some photographers like the resulting effect, while others do everything possible to avoid it. Vignette enthusiasts like the imperfect, analog feel the effect produces, and often use it to steer a viewer's gaze away from the edges and toward the brighter parts of the frame.

Technically speaking, vignetting occurs where the image circle begins to fade, so closing the aperture down by one or two f-stops makes the edge of the vignette sharper and helps to reduce its prominence in the image.

Figure 7-5: Just like when you view a subject from below, shifting the horizon also works when viewing a subject from above. In this view of Baltimore, Maryland, I shifted the horizon upward to emphasize the building in the foreground. Because the camera is only slightly tilted, the verticals remain largely parallel.
(17mm, ISO 200, 1/800 sec., f/6.3)

Shifting the lens moves the edge of the image circle closer to the edge of the sensor. If your particular combination of camera and lens makes it impossible to avoid the image circle entering the fame, you can simply use it as part of the composition. This is often the case with large-format cameras and lenses.

Figure 7-6: Maximum shift makes the image circle visible at the top edge of the frame. In this case, the effect works as an integral part of the composition.
(24mm, ISO 800, 1/160 sec., f/6.3)

7.1.4　Depth of Field

If you are shooting along a flat wall, you have the choice between using a large aperture with a shallow depth of field or a small aperture with greater depth of field. Tilt functionality gives you the best of both worlds and allows you to keep the entire subject in focus while using a wide aperture.

Figure 7-7: 24mm f/3.5, no tilt.
(24mm, ISO 100, 1/800 sec., f/3.5)

Figure 7-8: 24mm f/3.5, with tilt.
(24mm, ISO 100, 1/800 sec., f/3.5)

Tilt functionality enables you to superimpose the plane of focus on the subject plane. This doesn't increase the depth of field in the lens, even though the visual effect suggests it does.

To visualize a three-dimensional plane of focus, hold up a sheet of paper so that it hangs vertically and parallel to the image sensor. If you tilt the lens to the right, the plane of focus also tilts to the right around the vertical axis. In this case, the depth of field remains parallel to the plane of focus and the areas of defocus are tilted in three-dimensional space. In our wall example (figure 7-8), one area of defocus is within the wall, while the other is in front of it.

This technique allows you to use apertures that produce optimal focus while simultaneously allowing plenty of light to reach the sensor.

A good example of this type of application is an architectural shot along the front of a building. To keep the entire building in focus using a regular lens, you would have to use a very small aperture. A tilt-shift lens enables you to superimpose the plane of focus on the wall and thus capture the entire building in focus at maximum aperture.

Tilt functionality is most useful in situations where you need to keep multiple objects that are at various distances in focus.

7.1.5 Impossible Situations

Lens shift enables you to capture supposedly impossible scenes and even make yourself virtually invisible.

The Vampire Trick

Indoor situations present interesting photographic challenges. To maximize the feeling of space, architectural photographers usually use wide-angle lenses for indoor shots. These capture plenty of detail, but often end up including objects that don't necessarily belong in the final image. Reflective surfaces are tricky to deal with, and to ensure that the photographer doesn't end up in the photo, a mirror will often dictate the overall composition of an indoor image. Under normal circumstances, it is impossible to take a photo of a mirror head-on without including the camera or the photographer.

 Opposite:
Figure 7-9: Baltimore Inner Harbor, Baltimore, Maryland For this shot, I tilted the plane of focus to keep both the bollard in the foreground and the ship in focus while retaining a relatively wide aperture.
(17mm, ISO 200, 1/640 sec., f/10)

Figure 7-10: The camera is clearly visible in this head-on shot.

Figure 7-11: Moving the camera slightly to the side and shifting the lens in the opposite direction produces an apparently head-on image without the camera appearing in the mirror, and without any help from Photoshop!

Lateral shift in the lens enables you to photograph a mirror—apparently head-on—without you or the camera appearing in the shot. Here's how:

1. Set up your camera parallel to the mirror and move it sideways so it is no longer visible in the reflection.

2. Shift the lens in the opposite direction (i.e., back toward the mirror) so the mirror is once again located centrally within the frame.

Here, too, we are playing a game with parallel lines, although in this case it is the horizontal ones we are manipulating. They remain parallel, and infer that the viewer is viewing the scene from directly in front of the mirror. The scene looks as if it were captured by an invisible camera.

The Bridge Trick

A similar trick makes it possible to capture a bridge over a river head-on and shake-free without taking a boat or getting your feet wet. Here's how:

1. Set up your camera on the riverbank so it is parallel to the bridgehead.

2. Shift the lens until the center of the bridge appears in the viewfinder.

Once again, the parallel horizontal lines play a trick on the viewer's subconscious and infer that the photographer was located in the middle of the river when the photo was captured.

7.2 Landscapes and Nature

Tilt-shift movements are many a landscape photographer's most secret weapon, and are a great aid to creating fascinating, uncluttered compositions. You can use lens shift to emphasize the key element in a scene, or use tilt to simultaneously keep the foreground and the background in focus.

7.2.1 Infinite Depth of Field

Enormous depth of field is a signature attribute of many successful landscape photos, with every single detail in sharp focus, from the closest foreground all the way into the farthest distance. Landscape photographers often use a distinct foreground object to create a layered effect that lures the viewer's gaze deeper into the image. However, great

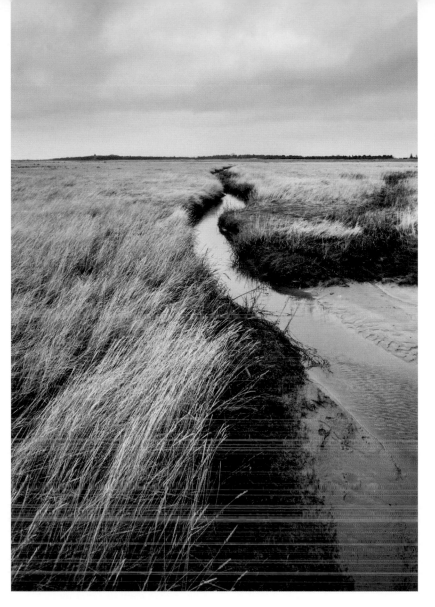

Figure 7-12: Sankt Peter-Ording, Germany
By tilting the plane of focus, this scene is in focus all the way to the horizon. Despite of the great depth of field, shifting the lens downward has placed additional emphasis on the grass in the foreground.
(24mm, ISO 400, 1/160 sec., f/5.6)

depth of field is normally only possible using a very small aperture, and small apertures tend to cause diffraction blur [17], which in turn reduces overall image quality.

Tilting the plane of focus forward until it is parallel to the ground is an elegant workaround for this issue. This way, depth of field remains parallel to the plane of focus (i.e., it is tilted along with the lens) and the defocused area beyond the field of focus lies beneath (or way above) the landscape. The end result is an apparently infinite depth of field, captured at maximum aperture.

The depth of field gradient no longer runs from front to back in the frame, as is usual, but instead from bottom to top. This makes tall objects

blurred toward the top, but you can compensate for this by stopping down the aperture, which increases depth of field toward the edges of the frame.

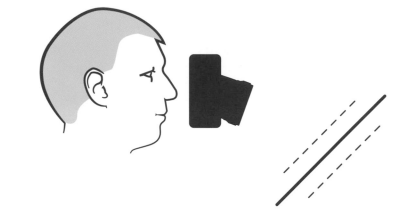

Figure 7-13: Tilting the lens tilts the plane of focus. Tilting the lens forward makes the depth of field gradient run from bottom to top in the image, rather than from near to far, as is usually the case.

7.2.2 Shifting Emphasis

Just like architectural photographers, landscape photographers often use lens shift to alter the visual emphasis within the frame. Using lens shift to move selected objects toward the edge of the image circle stretches and accentuates their proportions much more than simply tilting the camera.

Figure 7-14: Hexagons, Ethiopia Shifting the lens upward gives extra emphasis to the foreground. (24mm, ISO 400, 1/640 sec., f/6.3)

Figure 7-15: Basalt columns, Iceland These rock formations are highly reminiscent of human architecture. The verticals remain parallel thanks to the longer lens I used to capture them. (90mm, ISO 100, 1/125 sec., f/5.6)

7.2.3 Parallel Trees

Right angles are rare in landscape photos, so tilting the camera has a less obvious effect than it does in architectural situations. However, even in nature, you can't completely ignore the issue of converging verticals. Trees and other natural features grow vertically, and it quickly becomes obvious if the lens geometry bends these lines too much. This is where lens shift comes into play, just as it does in architectural shots. Use it to keep verticals parallel when you need to alter your framing.

Figure 7-16: Tilting the camera backward produces converging lines in the trees. However, in this case, the effect is so obvious that it is safe to assume it is deliberate.
(24mm, ISO 200, 1/200 sec., f/5)

Figure 7-17: Shifting the lens keeps the trees parallel with the edges of the frame. The message communicated by this image is completely different than in figure 7-16, and the difference is further emphasized by the square crop.
(45mm, ISO 100, 1/160 sec., f/5.6)

The approach here is basically the same as it is in architectural situations, even though there are no obvious vertical lines. Begin by setting up the camera using a spirit level so there is no tip in either axis. Now shift the lens vertically to get the composition you want.

If you don't have a level on hand, you can set up your camera by moving the lens to its zero position and then adjusting the camera until the horizon runs precisely through the center of the frame. Landscape photography doesn't require the same degree of precision that architecture demands and, ultimately, the composition and the message your image conveys are more important than the techniques you apply to achieve them.

For more details on leveling your camera on the fly, see section 7.7.

7.2.4 Water

Even a slight sideways slant in water makes a photo look strange to the viewer. Water is always level and we immediately notice if this isn't the case. One degree of tilt or less is sufficient to catch even an untrained viewer's eye.

Figure 7-18: Donegal, Ireland The camera is set up vertically and the lens shifted to keep the water looking level. (24mm, ISO 200, 1/250 sec., f/6.3)

Admittedly, the effect isn't too obvious if you tilt the camera backward or forward, and the strength of the effect depends on the focal length you are using. Nevertheless, tilted water has the potential to subconsciously feel unnatural, so it is worth the effort to use lens shift to combat it.

7.3 Panoramas

Figure 7-19: A panorama made from two parallel-shifted source images.

Tilt-shift lenses have their uses in panoramic photography, too. The conventional approach to shooting a panorama involves moving the camera up, down, left, or right around its own axis between shots and then stitching the resulting source images together using image-editing software. For more details, see section 5.8.

Stitching source images requires plenty of computing power, and the software has to correct converging verticals that result from the camera movements you make while you shoot. Multiple instances of rotation and geometric distortion have to be corrected, which can lead to unwanted artifacts appearing in the finished panorama.

Because a shift lens is really only a glorified wide-angle with an oversized image circle, it is logical to use one to create panoramas made from multiple parallel-shifted source images. The geometric discrepancies between the individual source images are slight, and will therefore simplify stitching.

This is how it works: use a tripod and shoot your source images with the lens shifted to varying degrees. To keep the look of your images consistent, make sure you don't alter the focus distance between shots, and be sure to use manual exposure metering and white balance settings. Because you are using shift instead of physically moving the camera, the angles of the lines in your images won't change between shots, so you might even be able to stitch your panorama manually without the use of dedicated software.

Figure 7-20: The upper source image, shot with the lens shifted upward.
(24mm, ISO 100, 1/1000 sec., f/3.5)

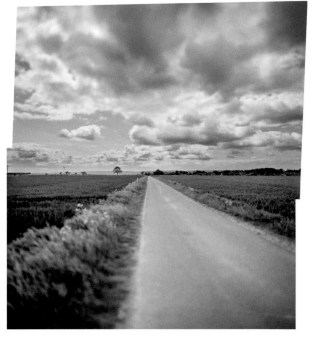

Figure 7-22: This is the result of stitching the two source images in Lightroom. Both only had to be slightly *bent* by the software, so I only needed to slightly crop the finished image.

Figure 7-21: The lower source image, shot with the lens shifted downward.

The geometric distortion involved in conventional panorama shooting techniques often requires heavy cropping once the source images have been stitched together. Using parallel shift to shoot a panorama greatly reduces how much you have to crop out of the finished image.

Figure 7-23: Mountain panorama, Sikkim, India.
Stitching the source photos leaves significant gaps at the edges of the finished image.

Figure 7-24: Even minimal cropping removes large areas of detail.

Figure 7-25: The cropped, final panorama.

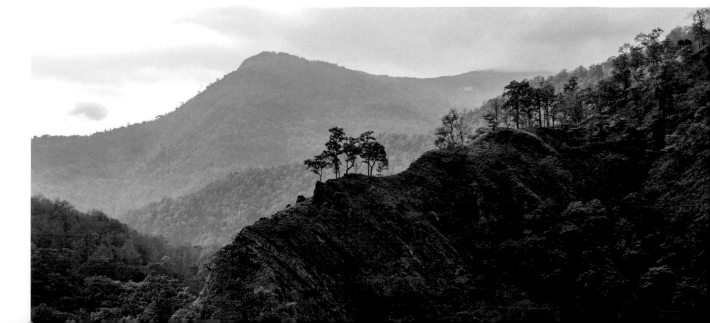

7.4 Product Photography

In product (or *tabletop*) photography, it is often a challenge to keep the plane of focus where it is required, especially when you use a medium-length lens and the camera is tipped forward toward the subject. These, too, are situations in which a tilt-shift lens comes to the rescue.

7.4.1 Controlling Focus

In tabletop photography the camera is nearly always positioned at an angle to the surface and the subject, which usually results in the plane of focus transecting the subject. Furthermore, tabletop photographers often use normal lenses and close subject distances that further reduce the available depth of field. If you use a tilt-shift lens, you can tilt the plane of focus to precisely coincide with the subject.

Imagine you are shooting a box set up at an angle to the camera and you need to capture a surface completely in focus. Instead of stopping all the way down and dialing up the flash power, the solution lies in the techniques we described earlier for architectural subjects. All you have to do is tilt the lens so that the plane of focus coincides with the surface you want to capture. This way, you don't have to use a small aperture and you retain maximum flexibility in your choice of exposure time.

Figure 7-26: The plane of focus divides the image in two, leaving the background elements out of focus. (45mm, ISO 100, 1/8 sec., f/6.3)

Figure 7-27: The same product photo, this time captured with the plane of focus tilted so it covers the front and rear elements of the subject. (45mm, ISO 100, 1/8 sec., f/6.3)

7.4.2 Controlling Distortion

The image projected by a wide-angle lens onto a flat image sensor produces obvious distortion toward the edges of the frame. Because a tilt-shift lens projects a larger image circle than an equivalent focal length lens, objects captured toward the edge of the image circle using the shift function will be more strongly distorted than usual.

This distortion causes objects to appear stretched—an effect you can use deliberately to emphasize selected image elements. For example, if you want to give an object in the foreground extra emphasis, you can use lens shift to alter its apparent size and make it appear larger in proportion to the rest of the image.

Figure 7-28: The camera has been tipped forward and the subject is reproduced with normal proportions.
(24mm, ISO 1600, 1/320 sec., f/3.5)

Figure 7-29: The camera is less tilted but the lens has been shifted. This moves the subject closer to the edge of the image circle and makes it appear larger, but also more distorted.
(24mm, ISO 1600, 1/320 sec., f/3.5)

7.5　Portraits

Tilt-shift lenses have their uses in portrait photography, too. You can use them to alter proportions or to produce unusual focus effects that steer the viewer's gaze.

7.5.1　Selective Focus

Contrast and sharpness are great tools for capturing and guiding a viewer's attention. In landscape and architectural situations, we often use tilt and shift effects to maximize the area of focus in a shot. In portrait situations, you can use a very different approach to make your photos more interesting. For example, you can tilt the plane of focus so that it transects your subject and leaves just a tiny portion in focus.

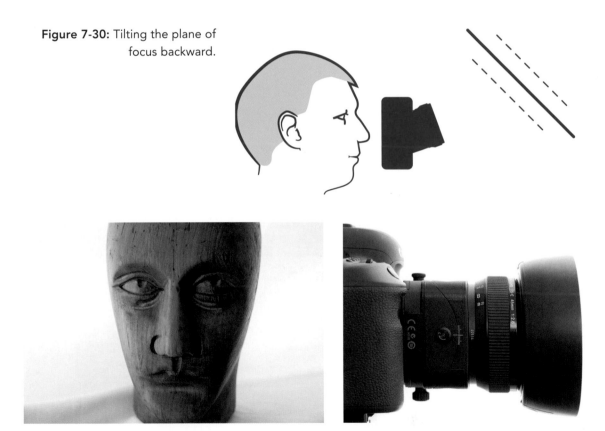

Figure 7-30: Tilting the plane of focus backward.

Figure 7-31: In this shot, Egon the hatmaker's dummy was captured normally using a medium aperture and a conventional plane of focus in line with his eyes. The areas in front of and behind his eyes are slightly out of focus.
(45mm, ISO 800, 1/200 sec., f/6.3)

Figure 7-32: The tilt-shift lens in its zero position.

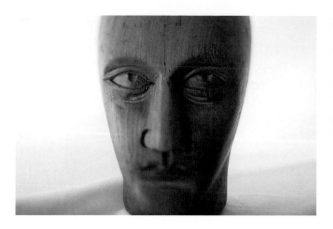

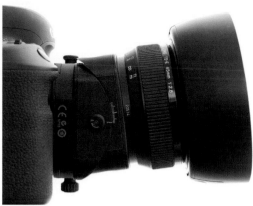

Figure 7-33: With the lens tilted backward, the plane of focus transects Egon's eyes. The rest of the frame (above and below the eye line) is out of focus. (45mm, ISO 800, 1/1000 sec., f/2.8)

Figure 7-34: The lens tilted upward.

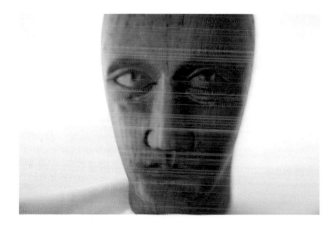

Figure 7-35: Rotating a tilted lens produces other interesting focus effects. In this shot, the plane of focus runs from bottom to top through Egon's left eye, leaving the areas to the right and left out of focus. (45mm, ISO 800, 1/1000 sec., f/2.8)

Figure 7-36: Sunset, Wicklow Mountains, Ireland
Unusual focus effects can be used to create exceptional landscape photos, too. Here, sideways tilt leaves only a tiny portion of the scene in focus. This effect immediately grabs the viewer's attention and makes for a highly unusual landscape image. (24mm, ISO 200, 1/1000 sec., f/4.5)

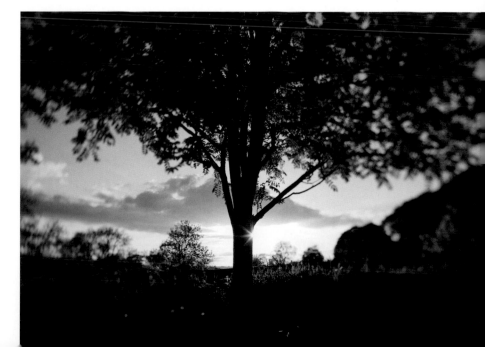

7.5.2 Longer Legs

You can use the "stretched" lines that occur toward the edges of the image circle for people photography, too. For example, if you shift the lens so that the edge of the image circle is in the focus zone, you can use the stretch effect to make your subject's legs appear longer. Wider-angle lenses are better for this type of situation as they produce stronger edge distortion than longer lenses.

7.5.3 Tricking Your Subject

Using a wide-angle tilt-shift lens and sideways shift, you can capture subjects that are positioned almost to the side of the camera and have them appear in the center of the frame. You can use this trick in street situations to make it look as if you are shooting past your subject. This helps you to remain inconspicuous and capture shots that you might otherwise miss.

Please be respectful when photographing strangers. For more on this topic, see section 4.3 on street photography.

7.6 Fake Miniatures

The popular *fake miniature* effect, which makes everyday objects look like small-scale models, is mainly created using tilt-shift functionality. For many photographers and videographers, learning about this effect was their first experience with the term *tilt-shift*. At its height, the fake miniature effect was omnipresent in the media, and even found its way into TV ads, although it is now well beyond its peak. Nevertheless, the effect itself is an interesting one, and it is worth taking a closer look at how it works. Not only is it technically challenging, it also depends heavily on human perception and subconscious visual expectations.

7.6.1 Pattern Recognition

When you have a repeated experience, you develop the expectation that the repeated event will be the same every time it occurs. In other words, humans are good at recognizing patterns and condition their behavior accordingly. One thing we are usually sure of is the visual effect of the focal length of a lens. A wide-angle reproduces spatial depth very differently than a telephoto, producing a different focus gradient and different proportions. Our expectations are particularly deep-seated in extreme situations, such as those found in macro photos. Macro shots are usually captured from very close up and have extremely shallow depth of field.

Experience tells us that insects are very small, and shallow depth of field tells us that a subject was captured from close up. These expectations confirm what we think we already know, namely that the insect in the photo is tiny.

Figure 7-37: Fly on a plant. Extremely shallow depth of field is one of the factors that help us recognize macro photos. (100mm, ISO 100, 1/400 sec., f/5.6)

7.6.2 Assumed Depth of Field

Tilt functionality is the essence of the fake miniature effect. While we use tilt to extend depth of field in landscape, architectural, and tabletop situations, in the case of fake miniatures we do the exact opposite.

Figure 7-38: Autobahn, Germany Captured with normal depth of field.
(24mm, ISO 100, 1/200 sec., f/7.1)

If we tilt the lens backward to apply selective focus (see section 7.5.1), the plane of focus transects the image space in an unusual direction. An image that previously looked normal suddenly presents a focus gradient that our visual expectations interpret as shallow depth of field. Our pattern recognition abilities play tricks on us. The altered focus gradient looks, on the surface, like that in a macro photo, so our visual perception jumps to conclusions and assumes that the object we are viewing is very small.

To fine-tune the illusion, there are other factors we can alter, too.

Figure 7-39: Tilting the plane of focus backward creates a look that is highly reminiscent of a macro photo, causing us to assume that the objects we are viewing are very small.
(24mm, ISO 100, 1/500 sec., f/3.5)

7.6.3 Other Tricks

Color Contrast

Kids' toys are usually brightly colored, and this is a feature we are familiar with from early childhood. The real world is less colorful, so increasing color saturation in a fake miniature photo accentuates the idea that the image contains toys rather than life-size objects.

Viewpoint

The best position to shoot fake miniatures is diagonally from above. Once again, remembered patterns tell us that this is the position from which we often shoot macro photos or how we view toys.

Lighting

Even the direction of the light can help underscore the miniature effect. Due to the short close focus distance in most macro lenses, the camera is usually positioned very close to the subject, so light in macro situations has to come from the side. This expectation, too, helps emphasize the miniature effect. For example, light in macro situations tends to come from the side, which also increases color saturation.

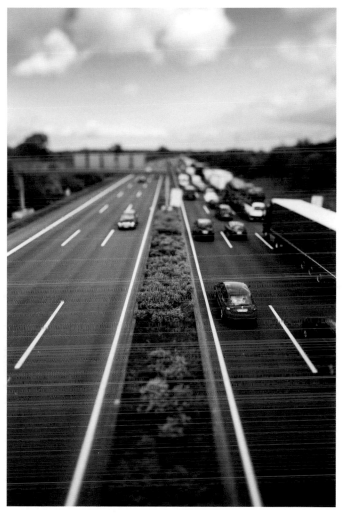

Figure 7-40: Increasing contrast and saturation strengthens the toy-town feel of the image.
(24mm, ISO 100, 1/500 sec., f/3.5)

7.6.4 Video Miniatures

Most of the effects we have discussed so far can be applied to video shoots, too. Unusual focus gradients, color effects, and contrast make video subjects appear tiny just like they do in still images. Because small subjects tend to behave in a more bustling manner (think of ants going about their daily routine), replaying video clips at higher speeds than normal underscores the miniature effect.

7.6.5 Fake Miniatures without Tilt-Shift

All of the miniature effects you can create using the physical attributes of cameras and lenses can also be produced using software, and there are plenty of apps and plug-ins available that use blur masking techniques to simulate shallow depth of field. While not perfect, the results are certainly close to those you can produce with a tilt-shift lens. Altering color and contrast on a smartphone is, of course, a snap.

The apps Snapseed (for Android and iOS) and Tadaa (for iOS) both include fake miniature functionality. This is how to create this kind of effect using Tadaa:

Figure 7-41: Open an image in Tadaa.

Figure 7-42: Create a mask and adjust it using pinch gestures.

Figure 7-43: Set the focus gradient.

Figure 7-44: Increase contrast and color saturation.

Figure 7-45: The finished image.

Figure 7-46: With a little practice, you can create successful tilt-shift shots without using a tripod. (24mm, ISO 100, 1/200 sec., f/9)

7.7 Handheld Tilt-Shift

Conventional wisdom says that you can only really use a tilt-shift lens effectively if you use a tripod to precisely set up your camera. I take a bit of an unorthodox approach, and have been successfully taking handheld tilt-shift photos for years.

Of course, a tripod is a great tool in nearly all architectural and landscape situations, and I wouldn't go out without one for most shoots. A tripod is essential for long exposures and is a fantastic aid to composition, allowing me to retain the camera's position until the light or the clouds are just how I want them.

Nevertheless, my tilt-shift lens has become my standard lens of choice in an increasingly wide range of situations. With some practice, I have learned to work quickly and flexibly, and the degree of precision I can achieve is nearly always sufficient.

7.7.1 Focusing Screens

One way to line up your camera without the help of a level is to use a focusing screen with engraved grid lines. Especially when you are using lens shift, you need to align horizontal and vertical edges, and using a focusing screen with appropriate reference points is surprisingly simple. The edges of the viewfinder image, too, are perfect for lining up the verticals in a building. If the edges of a facade are parallel to the edges of the viewfinder, you are guaranteed to have no converging vertical lines in your image. It is trickier to judge parallelism when the lines you are looking at are in the center of the frame rather than near the edges.

Many cameras have a viewfinder grid function that you can switch on when you need it, while some other cameras have interchangeable focusing screens with grid patterns that you can swap in and out as necessary.

The finer the grid, the more accurately you can work, but even a standard thirds-type grid is better than nothing.

Figure 7-47: The Canon Eg-D focusing screen, mounted in an EOS 5D Mark II.

Exercise

From the Settings menu, open the camera app in your smartphone and switch on the grid lines. Hold your phone so the vertical lines in your scene are parallel to each other and to the grid lines on the screen. Once this is the case, the camera is perfectly set up.

Figure 7-48: With the phone tipped backward, the converging verticals in the bookcase are visible.

Figure 7-49: The camera is tipped forward and rotated, which makes the verticals in the bookcase diverge upward and outward.

Figure 7-50: The verticals now match the edges of the frame and the grid lines, signaling perfect camera alignment.

7.7.2　Using the Horizon

In architectural situations, even slight unwanted tilt is quite obvious, whereas the lack of right angles in landscapes makes it easier to get away with a degree of imprecision. The best way to line up your camera in a landscape without the help of a level is to line it up with the horizon.

Begin with your lens in its zero position and set up your camera so that the horizon splits the viewfinder image in the middle. Now, without tilting the camera, shift the lens up and down to create your desired composition. Most people use the shift dial on the lens to adjust the lens position, but to be faster, I prefer to loosen the locking screw and push the shift mechanism of the lens by hand.

Once you have found the right shift position, use the viewfinder grid to note where the horizon divides the viewfinder image. This is the reference line for the setting you have made, and you can use it to ensure that the camera is correctly set up for all subsequent shots.

Epilogue: What Now?

By now, you have read all about getting started, composition theory, practical applications, and the technical side of wide-angle photography, including a detailed look at shooting with a tilt-shift lens. So what happens now?

The next step is to transfer what you have learned into real-world experience. If you have tried out all the tips and exercises included in the text, you will already have made plenty of progress. If not, now is the time to put the book aside, mount a wide-angle lens on your camera, and get out and shoot!

Figure 7-51: A combination of closeness, color contrast, plenty of depth of field, and the wide angle of view make this a compelling image.
(24mm, ISO 800, 1/4000 sec., f/3.5)

By far, the best and fastest way to come to grips with wide-angle photography is to leave your zoom lens at home. If you dare, on your next vacation, step out of your comfort zone and bring only a wide-angle with you. This might sound scary, but it's actually a great way to get a feel for the unique world of wide-angle shooting, even if it means you miss a shot or two that you might otherwise capture. Limiting yourself to a single wide-angle focal length forces you to think outside the box and to get creative.

Appendices

Appendix A
Weekend Project: DIY Full-Frame Pinhole Camera

A pinhole camera is a kind of ultimate wide-angle photo device that works without a lens. The image is focused through the pinhole, and the focal length is determined by the distance between the pinhole and the film. The shorter the distance, the wider the angle of view.

A DIY pinhole camera is a great project for a rainy weekend that also teaches you a lot about photographic focal lengths.

Materials:

- Roll of 35mm film (color negative ISO 400 film is fine)
- Empty 35mm film cartridge (ask for one at your local camera store)
- Empty matchbox
- Lightproof tape
- Piece of aluminum foil
- Needle

Project duration: 1–2 hours.

Take the drawer out of the matchbox and cut a rectangular hole in its bottom with about a quarter of an inch to spare on each side. Carefully pry the cap off the empty film cartridge. If you don't have an empty cartridge, you can always sacrifice an expired roll of film. Now feed the tip of the unexposed film through the sleeve of the matchbox, cut off the leader, and use tape to stick the end to the empty film spool. Push the spool back into the empty cartridge and put the cap back on, if neces-

sary sealing it with lightproof tape. Now put the drawer back into the matchbox so that it presses the film into the sleeve with the matte side of the film facing inward. Cut a ¼-inch hole in the opposite side of the matchbox and stick a piece of aluminum foil over it using lightproof tape. Make a pinhole in the center of the foil using the needle. Tape the matchbox up so that you can wind the film from the full cartridge into the empty one without exposing it to the light. You can use your finger as a shutter, but you get bonus points if you build an additional sliding shutter out of black cardstock.

The pinhole doesn't let in an awful lot of light, so you will need to go outside into bright light to use your new camera. Hold the camera very still (or set it down), aim it at a subject, and open the "shutter" for four or five seconds. Now cover the hole and wind the film. Once you have shot the whole filmstrip, simply cut off the loose end and take the full roll to a drugstore to have it developed. If you are really careful, your match-box camera might even be good for another roll of film.

The focal length of this particular camera depends on the depth of the matchbox, which is usually between 5mm and 10mm. Using 35mm film makes it a full-frame pinhole camera.

Figure A-1: The basic components: two film cartridges and a match-box.

Figure A-2: Empty one of the film cartridges.

Figure A-3: The drawer of the matchbox is transformed into a film carrier.

Figure A-4: Preparing the empty cartridge to receive the exposed film.

Figure A-5: The width of the matchbox fits the width of the film, which is exposed through the rectangle cut into the bottom of the drawer.

Figure A-6: Making a hole for the aluminum foil pinhole.

Figure A-7: The pinhole (in this particular case it ended up a bit too large) functions as a lens. For the photos shown in figure A-11, we used a pinhole made of lightproof self-adhesive plastic, but aluminum foil and lightproof tape work fine, too.

Figure A-8: Threading the film through the matchbox. Use tape to stick the end of the film to the empty spool.

Figure A-9: Use tape to lightproof the camera. The only place where light should enter is through the pinhole.

Figure A-10: A slider made of black cardstock serves as a shutter.

Figure A-11: The small format and the large pinhole produced rather blurry results, but the short distance between the pinhole and the film made for a nice wide angle of view. The indoor exposure times were between 1 and 2 seconds, but even these relatively short exposure times didn't make the images much sharper. For better results, use a smaller hole and fix the camera to a tripod or a wall, and remember to extend the exposure time to compensate for the smaller pinhole.

Appendix B Normal Focal Lengths for Popular Camera Formats

Format	Width	Height	Image Area	Diagonal	Normal Focal Length
Smartphone	10mm	7.50mm	75mm²	12.50mm	10mm
Micro Four Thirds	18mm	12mm	216mm²	21.63mm	20mm
35mm/Full Frame	36mm	24mm	864mm²	43.27mm	50mm
6×6cm Medium Format	60mm	60mm	3.600mm²	84.85mm	80mm
6×9cm Medium Format	60mm	90mm	5.400mm²	108.17mm	80mm
4×5 Large Format	101.60mm	127mm	12.903.20mm²	162.64mm	150mm
8×10 Large Format	203.20mm	254mm	51.612.80mm²	325.28mm	320mm

Table B-1: Normal focal lengths for popular camera formats.

Figure B-1: Switching center (24mm, ISO 100, 1/3 sec., f/9)

Appendix C Crop Factors

Sensor Size	Crop Factor
35 mm/Full-Frame	1
APS-C	1.5 – 1.6
Micro Four Thirds	2
Smartphone	approx. 7
4 × 5" Large Format	0.3

Table C-1: Crop factors

Focal Length	35 mm (factor 1)	APS-C (factor 1.5)	Micro Four Thirds (factor 2)	Smartphone (factor 7)	4 × 5" (factor 0.3)
18 mm	18	27	36	126	5.4
24 mm	24	36	48	168	7.2
35 mm	35	52.5	70	245	10.5
50 mm	50	75	100	350	15
80 mm	80	120	160	560	24
100 mm	100	150	200	700	30
150 mm	150	225	300	1050	45
200 mm	200	300	400	1400	60
300 mm	300	450	600	2100	90
500 mm	500	750	1000	3500	150
1000 mm	1000	1500	2000	7000	300

Table C-2: Equivalent Full-Frame Focal Lengths in Other Formats.

Appendix D Flange Focal Distances

Table D-1: Flange Focal Distances for Selected Camera Systems [18].

Type	Flange Focal Distance (mm)
Canon EF-M	18
Sony E	18
Micro Four Thirds	19.25
Canon EF	44
Nikon F	46.50
Olympus OM	46
Contax N	48
Mamiya 645	64
Pentacon Six	74.10
Mamiya RB67	111

Opposite:
Figure D-1: The Boss
(24mm, ISO 200, 1/125 sec., f/5.6)

Appendix E References

[1] The Viewfinder Villa regularly hosts photography workshops on a variety of topics—*https://viewfindervilla.com/en/*

[2] What does *bokeh* mean?—*http://www.sljfaq.org/afaq/boke.html*

[3] Gestalt Theory—*https://en.wikipedia.org/wiki/Gestalt_psychology*

[4] Parallax (or Ken Burns) effect—*https://en.wikipedia.org/wiki/Ken_Burns_effect*

[5] Interview with Henri Cartier-Bresson, *New York Times*—*http://lens.blogs.nytimes.com/2013/06/21/cartier-bresson-there-are-no-maybes/?_r=0*

[6] ND-Filter—*https://en.wikipedia.org/wiki/Neutral-density_filter*

[7] Donovan Wylie, photos of military watchtowers—*https://www.magnumphotos.com/arts-culture/donovan-wylie-british-watchtowers/*

[8] Depth of field calculator DOFMaster—*http://www.dofmaster.com/dofjs.html*

[9] Manhattanhenge—*https://de.wikipedia.org/wiki/Manhattanhenge*

[10] Rayleigh Scattering—*https://en.wikipedia.org/wiki/Rayleigh_scattering*

[11] PTLens—Software for correction of barrel/pincushion distortion, vignetting, chromatic aberrations, and perspective distortions—*http://www.epaperpress.com/ptlens*

[12] Scheimpflug principle—*https://en.wikipedia.org/wiki/Scheimpflug_principle*

[13] KEH CameraReseller for used cameras and lenses—*http://keh.com*

[14] B & H Photo Video—*https://www.bhphotovideo.com/c/buy/used-lenses-lens-accessories/ci/21426/N/4036297805*

[15] Lensbender Lenshield at Clickin Moms—*https://store.clickinmoms.com/lensbender-freelensing-solution/*

[16] Shift-Adapter from Kipon—
 http://www.kipon.com/en/product.asp?id=97
 Tilt-Adapter from Kipon—
 http://www.kipon.com/en/product.asp?id=89

[17] Diffraction—*https://wikipedia.org/wiki/diffraction*

[18] Flange focal distance—*https://en.wikipedia.org/wiki/Flange_focal
 _distance*

Figure F-1: Yurt
(24mm, ISO 200, 1/500 sec., f/8)

Index

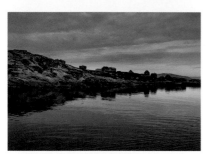

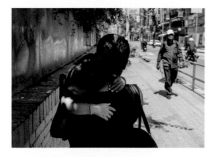

Don't close the book on us yet!